Learn to Paint

PORTRAITS

Roger Coleman

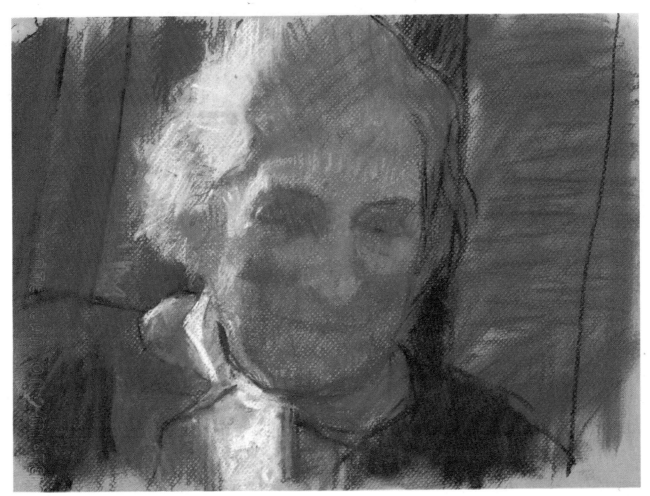

COLLINS

D0452727

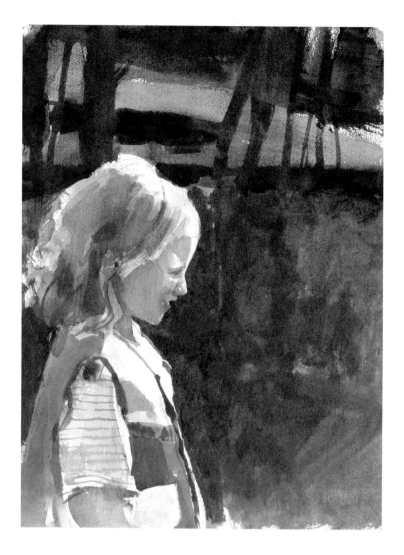

First published in 1988
by William Collins Sons & Co. Ltd
London . Glasgow . Sydney
Auckland . Toronto . Johannesburg

© Roger Coleman, 1988

Edited by Josephine Christian
Designed by Caroline Hill
Photography by Ben Bennett and Nigel Cheffers-Heard

British Library Cataloguing in Publication Data
Coleman, Roger
 Learn to paint portraits. —— (Learn to
paint series).
 1. Portrait paintings – Manuals
 I. Title
 751.4

 ISBN 0–00–412160–0

Filmset by J&L Composition Ltd
Filey, North Yorkshire
Colour reproduction by Bright Arts, Hong Kong
Printed and bound in Italy
by New Interlitho, SpA, Milan

CONTENTS

PORTRAIT OF AN ARTIST
ROGER COLEMAN

Roger Coleman was born in 1930, in an industrial village near Leicester. He studied painting at Leicester College of Art from 1948 to 1951, and it was during this time that he became particularly interested in portrait painting. In 1952, while he was doing his National Service with the Royal Artillery, he won a national portrait painting competition.

After National Service he spent four years studying at the Royal College of Art, and became editor of the college journal, *Ark*. When he left college he joined the staff of *Design* magazine as an assistant editor. He spent the next few years working for *Design*, writing and broadcasting on art, design and television, and, as a member of the exhibitions committee at the Institute of Contemporary Arts, organizing art exhibitions. He did very little painting during this period. In 1959 he returned to painting and he also started to do illustrations, mostly for news magazines. During the 1960s he achieved a world-wide reputation as an illustrator.

It was in the early seventies that he moved from London to the village of Burpham, near Arundel, on the Sussex Downs, where he now lives with his wife and two daughters. Since then he has devoted almost all his working time to painting. His works include landscapes and sporting pictures – and hundreds of portraits, mostly of his family and friends. In 1980 *Downland*, a book of Roger Coleman's paintings of Burpham, its characters and its surroundings, was published by the Viking Press.

BELOW **Fig. 1** Roger Coleman working in his studio

OPPOSITE **Fig. 2** *Self-portrait* 1979 oil on canvas 40 × 40 cm/16 × 16 in

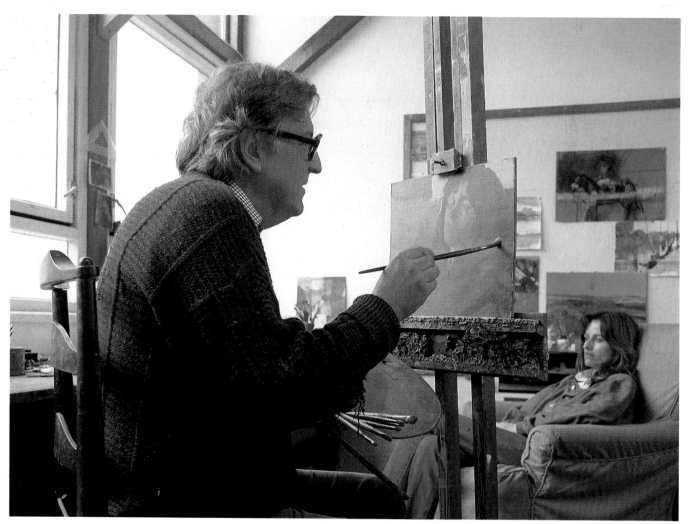

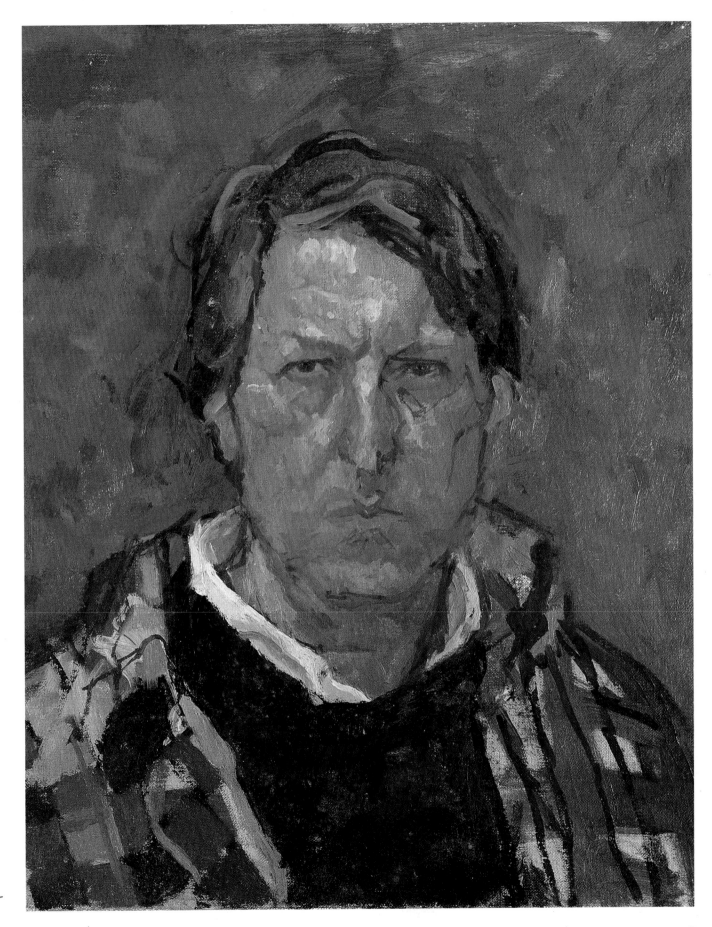

WHY PAINT PORTRAITS?

Until about the middle of the last century, most paintings were commissioned from the artist as a job of work. A painting would be done to a pre-agreed specification and with a particular application in mind: notions of self-expression, today regarded as the artist's true province, came a lot lower on the scale of priorities – if they appeared on it at all.

Portraits, especially those of the great and powerful, were positively hemmed around with specifications. The political implications of the likenesses of popes, emperors, generals and their kind were at least as significant as the artistic aspects. The portrait of a king was intended to symbolize his kingship rather than to disclose his character as a human being. Indeed, often the actual, physical appearance was modified to provide whatever regal attributes were held desirable. For example, there is a portrait of the Spanish King Philip IV by Velazquez, one of the greatest of all portrait painters, which was entirely repainted, some five years after its completion, precisely along these lines. X-ray photographs have revealed, in the first portrait, an altogether less glamorous individual – shorter in the neck, double-chinned and larger round the waist – a much less convincing candidate for the divine right of kings.

In the eighteenth century the numbers of those eligible, as it were, to have their portraits painted increased enormously; in England and Scotland this period was the high point in portraiture – think of all the stately homes lined with family portraits. With the exception of Turner and Constable, all the most famous British artists of this period were, professionally speaking, portrait painters: Reynolds, Gainsborough, Ramsay, Raeburn, Romney, Lawrence, among them. Whatever other kinds of painting these artists aspired to, their bread and butter came from painting the faces of, now, not only royalty and the aristocracy but also members of the new, rising middle classes – farmers, landowners and brewers, as well as actors, writers and people from the more raffish reaches of society.

Gainsborough complained in his letters of the need to paint faces all the time, when what he really wanted to do was to get out into the country, make music and paint landscapes. Similar feeling was expressed by John Singer Sargent at the end of the nineteenth century. Sargent, anachronistically, was the last of the great professional portrait painters in the sense that Gainsborough and Lawrence were professionals. By his time, the tradition that had enabled Gainsborough and Raeburn to paint bread-and-butter portraits that were at the same time great paintings was almost exhausted. In the twentieth century most of the best portraits have been painted by artists who are not professional portrait painters, painting people (often family or friends) not to fulfil a commission, but because they want to paint them. Picasso, Walter Sickert and Wyndham Lewis, for example, all professional painters but certainly not professional portrait painters, produced some wonderful portraits. On the other hand, professional, commissioned portrait painting now often tends to result in images that are vapid and bland.

Some years ago John Rothenstein, talking of Augustus John, spoke of how in the past an artist was sustained by a workmanlike and dignified tradition; and how the waning of this tradition had left the present-day portrait painter face to face with his sitter, dependent, as his predecessors were not, on his *personal* response to the face in front of him. Which is the position of us all, professional and amateur alike. Today the answer to the question, 'Why paint portraits?' is simply, 'Because I want to do it'. Because painting a portrait is very, very interesting, to the painter and to the sitter.

Having just implied that you can follow your feelings when you paint, I shall now tell you that you should do no such thing. When I say that I paint portraits for pleasure – and I do, I seldom paint portraits professionally, I almost always do them just because I want to – I do not mean that there are no guidelines or constraints.

The basic minimum requirement of a portrait is that it should look like its subject. This is all very well as long as we do not inquire too closely into what we mean by 'like'. We all know what we think we mean; but to paint a likeness we have to be a bit clearer. First, it helps if you know the kind of thing you want to achieve: what kind of likeness do you want? In the case of the Velazquez portrait mentioned earlier, the first, painted-over version was 'like' the man, whereas the second could be said to be more 'like' the king, and, since the enhancement of majesty was one of the painter's obligations, you could argue that the second was a more satisfactory likeness than the first.

However, nowadays when people speak of a portrait being 'like' its subject, they will most probably be thinking in terms of a photographic likeness. But it would be wrong, certainly from the painter's point

Fig. 3 *Jack Lloyd* 1979 watercolour portrait painted for *Downland* 38 × 56 cm/15 × 22 in

of view, to regard the camera as providing an absolute standard by which the look of things can be understood. The camera is a wonderful recording instrument, but it does distort: insidiously, since people seldom appreciate that it does, or at least the ways in which it does. 'As good as a photograph', people comment, when they wish to compliment an artist on the fidelity of his rendering of, say, his wife's features. Later in this book (pages 38–41) I shall deal in more detail with the way a painter can use photography, and with some of the problems that can arise from too enthusiastic an acceptance of its convenience.

There are many examples of impressive photographic portraits, taken by perceptive, talented and skilled photographers. Great photographers have produced photographic portraits that are great works of art. But in the last analysis the camera records its print impersonally, and surely a portrait ought to be more than that: should it not be a human reaction to a human being? But if so, is not the painter then primarily concerned with something beyond, or underlying, the facts? The practical answer to this second question is no. A portrait painter is concerned with the facts, you might argue exclusively so, and a good portrait has to treat seriously the shape, proportions, texture and colour of the sitter's face, observing them closely and measuring them carefully. But what about the character of the sitter, the psychology, is not that what portraits are about?

What you can say with confidence is that there are painters (Rembrandt comes to mind, Holbein and Velazquez too) whose portraits tempt one to psychological, even spiritual speculations; there are also portraits which you feel are profound assessments of a personality, even though you do not know that personality. At the other end of the scale there are portraits that are technically quite competent but nonetheless shallow and inert.

But however much you use words like 'insight' or 'perception' to explain the effects of a likeness, the painter must concern himself most with physical problems such as proportion, application of paint, composition and colour, and get them in the right combination to make a good picture.

Whether or not Rembrandt consciously, as it were, employed the spiritual insight credited to him when he was painting, I do not know, but I rather doubt it. The demonstration of feelings, emotions and attitudes, any sort of 'interpretation', in fact, other than the most general, practically unconscious sort, does not help, and stands a good chance of hindering, the creation of any kind of a portrait. Any artist will have his work cut out simply translating the way the model appears to him into paint on canvas, without adding the difficulties of character analysis. It is equally unprofitable to consider the 'meaning' of the sitter's features, which do not constitute an index of human characteristics – for example, to equate high foreheads with nobility and cling to notions about close-set eyes, mean mouths, and, as my grandmother used to, criminal ears.

The depth we perceive in great portraits seems to arise, almost without the conscious participation of the painter, from the physical process of making the picture, not from his psychological speculations. Of course, in the situation of most amateur portrait painters such speculations will hardly be invited, since, unlike the professional, they will not be meeting the sitter for the first time at the first sitting. Amateurs (and I count myself as a portrait amateur, although a professional painter) usually paint family or close friends, and will therefore be free from the temptation to read all sorts of traits in, and project all sorts of characteristics on, the friendly features facing them.

All they have to do is paint.

7

EQUIPMENT

I have always felt that it is an error to make a mystique out of your equipment, buying it for its own sake, or because it looks nice, which it can. Start with the basic essentials and add to them if you need to. Obviously, if you are starting from scratch you will need guidance from some source: the following recommendations are not the results of exhaustive tests, but I think they are as sound as any.

I can only recommend what I use myself, so I shall go through the mediums I use, giving my suggestions.

I draw in pen and ink (which includes fibre-tipped pens), pencil and charcoal, and paint in oil, watercolour and pastel, and very, very occasionally in acrylic.

Pen and ink

The pen I use most of the time is a mapping pen. Some people find that mapping pens are a bit fine, and do not produce a strong enough line; but since my pen drawings are usually not very large, this does not worry me. What I do like about mapping pens is their flexibility, the way they respond to changes in pressure, producing lines of different strength and character. I use a black Indian ink, such as Daler-Rowney's Kandahar, and, on odd occasions, brown or sepia (of course, waterproof inks come in the basic colours should you need them).

Fibre-tipped pens are available in a wide range of thicknesses, from very broad indeed to extremely fine. Again, as most of my drawings are small, I generally prefer a fine one.

Pencil

Pencils are graded in degrees of hardness, from 6H, the hardest, to 6B, the softest, with HB at the mid-point. The H grades are intended largely for technical drawing. Hardness and softness are relative notions, certainly relative to the surface they are used on – a line with an HB on, say, brick or plaster will seem soft, as a line in 2B on glossy paper will seem hard. It is not necessary to buy a whole range of pencils: start with HB, B and 2B and add if you need to. I use a 2B for most pencil drawings, though I sometimes use a softer grade if I am doing a drawing with a lot of dark tone in it. 2B is also about the right weight for pencil indications at the beginning of a watercolour – soft enough not to dent the paper, which would show when the wash was laid, but sufficiently hard not to make dirty marks.

Charcoal

I use charcoal both as a drawing medium in its own right and as a means of indicating the basic proportions on a canvas before starting to paint.

Charcoal comes boxed in three weights – thin, medium and large. I use thin and medium sticks. You will need to fix charcoal drawings, using a special charcoal fixative. This is available either in a bottle with a blow-spray or conveniently packaged in an aerosol. You will also need a soft putty rubber, which will erase charcoal marks cleanly.

Oil paints

Artists' colourmen produce enormous ranges of colours in oil paint. Daler-Rowney, for example, have a list of eighty-eight colours. Some of these will be 'fugitive' (that is, subject to fading and alterations) and others only 'moderately permanent'. On the other hand, very few artists use more than a dozen or so. The aim should always be to use as few as you can. Titian, it is said, used nine, and Rubens, fourteen.

On occasions I have used as few as five (Titanium White, Cadmium Lemon, Cadmium Red, French Ultramarine and Ivory Black), but I generally select from about nine to a dozen. Subject-matter will affect your choice of colours to some extent, but the following list should enable you to tackle most things: Titanium White, Cadmium Lemon, Cadmium Yellow, Yellow Ochre, Raw Sienna, Burnt Umber, Indian Red, Cadmium Red, Crimson Alizarin, French Ultramarine, Cadmium Green and Ivory Black. To this list you could add two blues, a phthalo blue, such as Monestial Blue, and Cerulean or Coeruleum (the spelling is immaterial), a very light blue useful for cooling flesh tints. Some people find Viridian an indispensable green and Cobalt Blue an indispensable blue – I do not.

Be wary of Indian Red, Crimson Alizarin and the phthalo blues: they are all very dominant colours, and can easily saturate your mixtures if you are not careful.

All colours are available in two qualities, Artists' and Students'. Artists' are finer in quality and consequently more expensive.

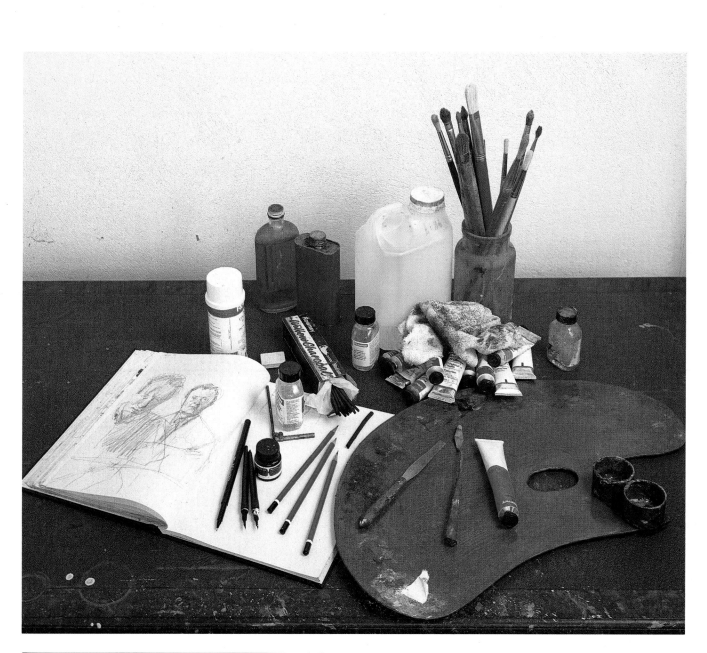

Fig. 4 Basic equipment for drawing and oils

Key

1 Aerosol fixative
2 Linseed oil
3 Drying medium
4 Retouching varnish
5 White spirit
6 Brushes for oil painting
7 Rag
8 Oil paints
9 Wax varnish
10 Palette
11 Dippers
12 Gel medium
13 Oil painting knife
14 Palette knife
15 Charcoal
16 Putty rubber
17 Fixative
18 Spray diffuser
19 Pencils
20 Indian ink
21 Mapping pens
22 Fibre-tipped pen
23 Sketchbook

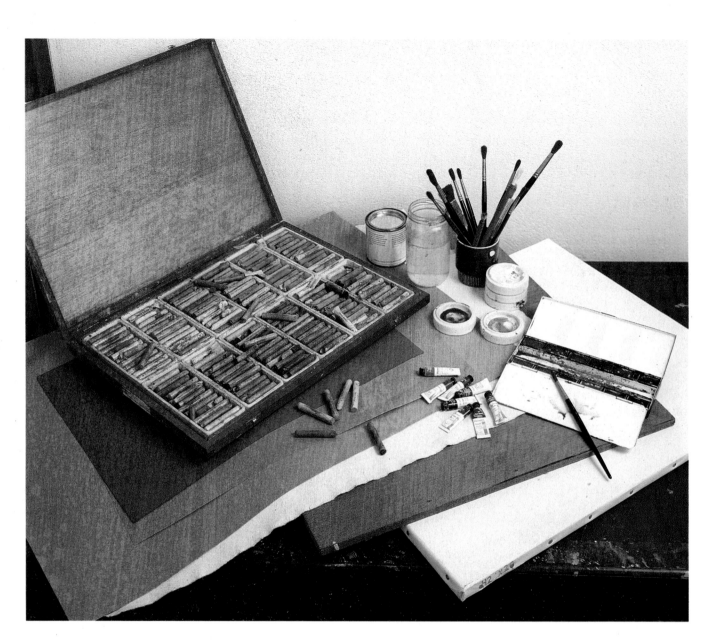

Fig. 5 Basic equipment for watercolours and pastels

Key

1 Box of pastels
2 Acrylic 'gesso' primer
3 Water jar
4 Watercolour brushes
5 Ceramic palettes
6 Watercolour box
7 Canvas
8 Plywood
9 Watercolour paper
10 Coloured pastel paper
11 Tubes of watercolour paint

For years I diluted oil paint with a mixture of linseed oil and turpentine – more turpentine than oil. But recently I have used a gel drying medium. As a student I was always taught to avoid drying agents of any kind, but manufacturers claim that the new ones based on synthetic resin are free from vices. If you have no need to speed up the drying time of your paint, don't take any risks, stick to the oil and turpentine mixture.

Watercolours

Watercolours are available in pans, half-pans (the usual components of a watercolour box) and tubes. I prefer tubes, which I squeeze into the pans of a watercolour box. You can get boxes containing almost any number of half-pans. I have several boxes, but the one I use most of the time contains twelve whole pans in which I put out the following colours: Aureolin, Cadmium Yellow, Yellow Ochre, Raw Sienna, Raw Umber, Burnt Umber, Cadmium Red, Crimson Alizarin, Coeruleum, French Ultramarine, Monestial Blue and Oxide of Chromium. To this list of colours you could add Ivory Black (it is seldom you will need black in watercolour), Cadmium Lemon and Light Red. This selection is an all-purpose one suitable for most subjects.

When the need arises I use white gouache mixed with watercolour to give a less transparent pigment. Sometimes the need is simply to retouch small details. At other times it may be necessary to cover substantial areas with opaque paint.

Pastels

You can buy pastels in different-sized boxes. Daler-Rowney's boxes range from a basic set containing twelve assorted colours right up to 144. There is a useful box containing thirty-six sticks which should provide the beginner with a large enough range to see whether the medium appeals or not. You can also buy the colours individually: there are over 190 tints to choose from in the Daler-Rowney range.

You will also need a fixative, of the type used for fixing charcoal drawings (see page 8).

Acrylics

With acrylics, as with all mediums, your choice of colours should be guided by simplicity. Mine would be Cadmium Yellow, Yellow Ochre, Raw Sienna, Venetian Red, Cadmium Red, Permanent Rose, Ultramarine, Monestial Blue, Bright Green, black and white. As well as the colours, you can get supporting products such as retarder to hold back the drying time, and texture paste to give the paint body.

Brushes

There are two general rules about brushes. The first is to buy the best you can afford. The second is always to use one size larger than the size you first thought of.

Hog-hair brushes are, for all but the smallest paintings, quite the best means of applying oil paint. Of the various shapes you can obtain I use just two, the round and the filbert shapes. I avoid square-ended brushes and have always urged students away from them, as I think they can easily lead to mannered ways of applying paint.

For watercolour painting, pure sable brushes are the best. They are also very expensive, but they do come in different grades priced accordingly. Brushes made of ox-hair or a mixture of ox-hair and sable can also be used for watercolours. Numbers 5, 6 and 7 are the most useful brush sizes, and even a number 7 brush, if it is a good one, will be quite suitable for detailed work.

Then there are the synthetic brushes which are advertised as being suitable for watercolours, oil paints and acrylics. My own experience, using them for oil paints, has been less than satisfactory, but I know people who use nothing else.

In the end, use the brushes that you like using and feel comfortable with, no matter what the experts tell you – providing, of course, that you also feel happy with the results.

Supports

The traditional support for oil paintings is, of course, canvas, which is a joy to use and is very light in weight – a consideration if you paint large pictures. It is expensive, though.

Hardboard can be used – the smooth side, not the textured side, which has far too aggressive a pattern, and plywood is a particular favourite of mine. Less usual, perhaps, but a very satisfactory surface for oil painting, is paper; it needs to be fairly thick, certainly not less than 290 gsm (140 lb) in weight (see page 12). Any surface to be used for oil painting must be primed either with size or with an acrylic primer. There are many traditional recipes for primers, but nowadays most people use acrylic gesso.

Paper for watercolours are very much a matter of individual choice. Finding one you like can involve a lot of trial and error. Watercolour paper is made in three surfaces, Rough, HP (hot pressed) and Not (not hot pressed): the Rough, quite reasonably, is rough and the HP is smooth, with the Not somewhere in between. I use a Not paper most of the time, and this is the surface I would recommend to anyone beginning watercolour painting.

Watercolour paper is graded by weight, stated either in grams per square metre or as the weight of a ream in pounds. Obviously, the thicker the paper the heavier it is. The weights of paper generally used for watercolours range from about 150 gsm (72 lb) to 425 gsm (200 lb).

The thinner papers need to be stretched before use, or they will cockle. To stretch a piece of paper, first wet it thoroughly, then fasten it to a drawing board using strips of gummed paper (not sticky tape). The paper will dry taut and flat. However, I don't like stretching paper myself – it makes me nervous, and the time taken doing it acts as a constraint. Watercolour is a medium that profits from boldness, and I want to feel able to use the paint freely and confidently. So I always use a paper heavy enough not to cockle when the water is put on, that is, with a minimum weight of 290 gsm (140 lb). For watercolour white paper is almost always preferable to tinted.

Acrylic can be worked on virtually any support or surface, from raw canvas to paper. Since acrylic is a plastic paint it will not crack, as oil paint can, so a firm support is not functionally necessary. Again un-like oil paint, it does no damage to the support, so no priming is necessary on that score. However, acrylic gesso provides a pleasant surface to work on and cuts down the 'tooth' of canvas.

Pastel, too, can be applied to any surface. It is best, though, to avoid the extremes of roughness and smoothness. A support with too assertive a tooth makes the soft pigment sticks difficult to handle. And at the opposite pole a very smooth paper can also lead to difficulties, as the pastel may clog the paper's texture too quickly.

Other equipment

You will also need a drawing board (a good size is half-imperial – 38 × 56 cm/15 × 22 in), a sketchbook and a palette knife. And you will need an easel. You can hold a drawing board with one hand and draw with the other, but you can't paint like that; the canvas, or whatever, must be held firmly so that it remains in constant relationship to your subject. There are several kinds of easel to choose from – sketching ones that fold up, radial easels such as you find in art schools, and the table-top variety.

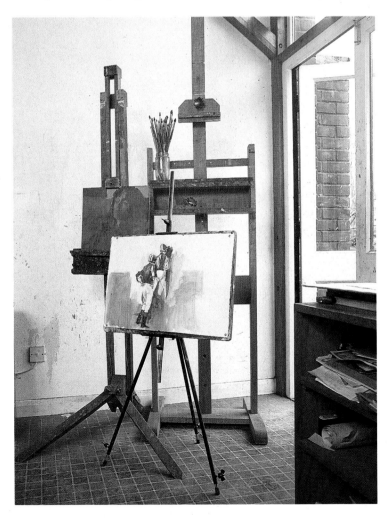

Fig. 6 Easels in the artist's studio. From left to right: radial easel, studio easel, watercolour easel with drawing board

ANATOMY

All artists concerned with the human figure should have some knowledge of anatomy. They should have an idea of how the body is constructed, how it articulates, and the manner in which the parts under the skin give rise to the bumps and concavities on the surface. Such knowledge is a great help in realizing more clearly the figure you are painting. Here I am limiting a vast and intensely interesting subject to a brief study of the skull and its muscles as they immediately affect the portrait painter. However, I would urge students who seriously want to draw or paint the figure to enlarge on these notes for themselves, by consulting one of the many books that deal with anatomy for artists.

The bones, of course, are the support of the body – its structure. While their shape cannot be seen directly, they affect appearance more than one might at first imagine. They are not uniformly covered with muscle, and there are significant parts of the body where the bones are close to the surface of the skin: the knuckles are an obvious example; so, more importantly in our case, is the skull. Where bones are close to the surface you get clear and well-defined highlights, as the skin is smoother and tighter than in areas where the bone is deep or where the muscle hangs away from it.

The bones of the head

Fig. 7 shows front and side views of a skull, with the principal bones marked. A portrait painter will find that the following points, particularly, are worth keeping in mind.

Only about half the nose is bone: the lower part, which is the most variable and characteristic, consists of cartilage.

The white and iris of the eye are simply the parts of the eyeball which show: the remainder is located behind the rim of the eye socket. Always try to sense where the rim is on your subject – often, particularly with thin people, it is easy to see. The part of the eye surround that 'bags' with age, which is muscle, can overlap the rim at its bottom edge.

It is very clear from a plan view that the teeth are arranged in a sort of arc. Students who fail to appreciate this tend to draw them flat on to the front of the face, looking a bit like a car's radiator grill (not even the two upper front teeth are flat). Remember, the top teeth usually, though not always, overlap the bottom ones.

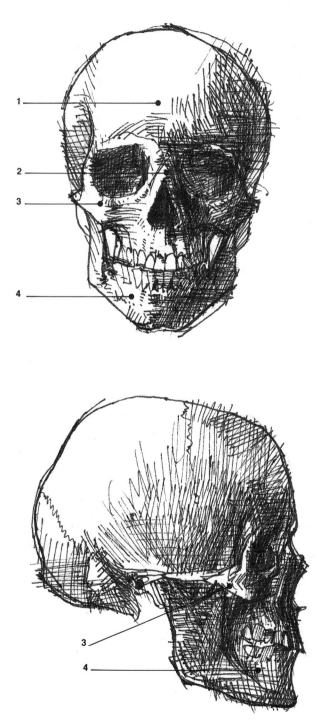

Fig. 7 The bones of the skull, front and side views
1 Frontal bone 3 Zygomatic arch
2 Nasal bone 4 Mandible

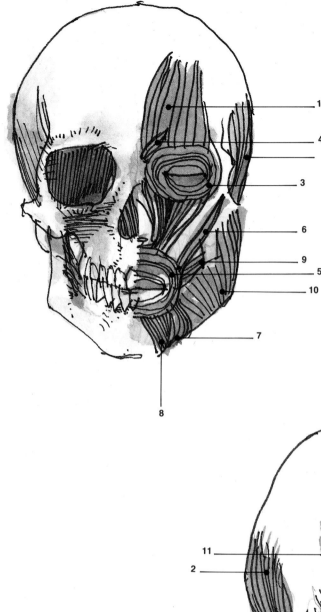

Fig. 8 The muscles of the head, front and side views

MUSCLES OF THE SCALP

1 **Frontalis:** covers the forehead, reaching from above the eyes to the galea (the tendon-like sheath that covers the skull), and moves the galea and the skin of the forehead

2 **Occipitalis:** located at the lower back of the head (invisible except in the bald), it moves the galea backwards

MUSCLES OF THE FACE

3 **Orbicularis oculi:** covering the eye socket and eyeball, including the eyelids, its function is to open and close the eye

4 **Corrugator:** draws the eyebrows towards each other, in frowning

5 **Orbicularis oris:** encircling the mouth, it is used in opening and closing the mouth and in pursing the lips

6 **Zygomaticus major:** pulls the mouth upwards, as in smiling

7 **Depressor anguli oris:** pulls the mouth down

8 **Depressor labii inferioris:** pulls the lower lip down

9 **Buccinator:** the muscle used when you blow

10 **Masseter:** a strongly defined muscle, it closes the mouth, as in chewing

11 **Temporalis:** fills the temple and attaches to the lower jaw behind the zygomatic arch: a chewing muscle

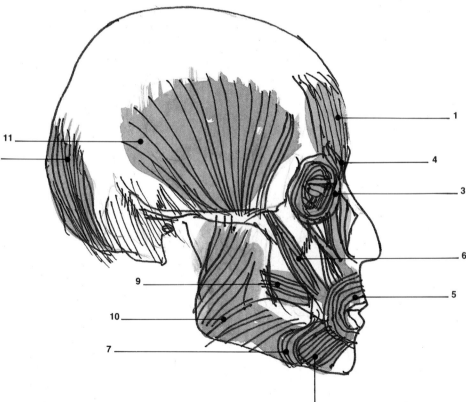

The muscles of the head

The principal muscles of the head are marked in **fig. 8**. It is important to understand what they do and the direction in which their fibres run, as this affects the surface appearance.

14

LIGHT

Light often provides the motivation for a painter. Frequently, I will start to paint a portrait because I have been struck, not so much by the face of the subject, as by the way light happens to fall on the cheekbone, or the nose.

But many amateur painters will set up a still-life or a portrait in a way which shows a lack of awareness of how the light is behaving. A painter may want to paint something because he feels that it has a beautiful shape or colour, and fail to realize that the shape can be obliterated by bad lighting, and the colour adulterated by unwanted reflections.

Much of the character of a portrait resides in the way light is used. Most Old Master portraits are lit very simply, with the head light against a dark background. This approach not only concentrates attention on the head, but also makes it easier to relate the details of the features to the head as a whole. The light itself generally comes from a single source, three-quarters on to the face and well above the sitter's head. The effect of this is to illuminate the front of the head and to confine the significant area of tone to one side or the other. The head has a light side and a dark side. The sketches after Velazquez in **figs. 9** and **10** show how this works. It is dramatic lighting, and it simplifies complex areas, such as that around the eye and the eye socket. It brings closer the tones of iris and pupil and completes the description of shape with a single highlight.

Rembrandt used light in the same basic way, but exaggerating it for even more dramatic effect. He

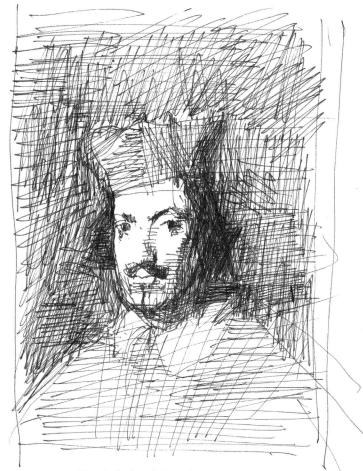

BELOW LEFT **Fig. 9** A sketch based on a portrait by Velazquez
ABOVE **Fig. 10** A sketch based on a portrait by Velazquez
BELOW **Fig. 11** A sketch based on a self-portrait by Rembrandt

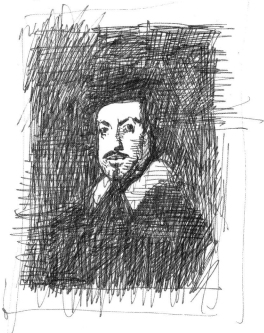

15

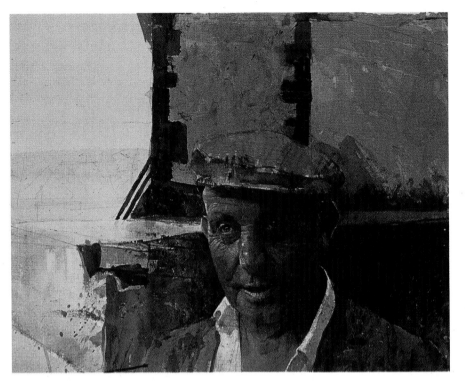

Fig. 12 *George Gent* 1978 watercolour portrait painted for *Downland* 38 × 56 cm/ 15 × 22 in

would pose the sitter, often himself, so that the face seems to be turning either away from or towards the light (see **fig. 11**). Sometimes the eyes are half-concealed in deep patches of shadow, with forehead, nose and cheekbone illuminated.

The light we see in Old Master portraits is not the light we experience from day to day. Until the Impressionists and their immediate precursors took their easels into the open air, artists were generally confined to the studio. (Even a portrait with an outdoor setting would actually be painted in the studio.) Inside the studio the painter would control the amount and direction of the light coming in, using it to simplify and emphasize those aspects of the subject he thought significant. This is very evident in the portraits painted by the Old Masters, where the light seems to fall only on the face and enhances the form. The painter would also try to ensure that the light falling on his subject did not vary. This is why, traditionally, studios face north: light coming from the north generally remains constant throughout the day, whereas light coming from other directions gets warmer as the day progresses.

The bright daylight sought by the Impressionists tends to flatten the subject, making it more difficult to see the simple volumes. And, of course, it is infinitely variable.

Since the Impressionists taught us to regard light and colour as inseparable, we have been inclined to overlook the role of light as an illuminating agent. Consequently, modern paintings tend to be composed of areas of colour rather than areas of light and shade. In modern portraiture, structure is most often sought through the analysis of colour, not through the interplay of light and dark masses. This tendency is reinforced by the images of modern life, in which colour plays a more expressive role than light. The even, strong light that shines on television newsreaders, say, produces a detailed, colourful but rather flat image. On the other hand, most photographs, especially amateur snapshots, are terribly complicated, because the light is coming from many different directions.

The average amateur painter is not going to be able to create the ideal lighting conditions of a traditional artist's studio; nor, perhaps, would he want to. He can, though, learn an important lesson from the Old Masters, and when lighting a subject strive for simplicity. A model should always be posed so that the light is falling as simply as possible. And look for that light against dark effect that gives such a strong, convincing image.

Experiment, moving around a table lamp or even a candle, to see how light affects what you are going to paint. Experiment, too, with different backgrounds – you can learn a lot by just placing pieces of paper or card in various tones and patterns behind your subject.

Another useful exercise is to practise drawing a head, ignoring all the detail and reducing it to simple masses of light and dark. Confine yourself to three tones – dark, light and one middle tone – and try to get the feeling that one side of the head is lit and the other is in shadow.

16

TONE AND COLOUR

In any painting the relationship between tone and colour is critical.

Tone

The question of tone is a very important one in painting. Most of the shortcomings to be found in amateur painting can be traced to difficulties with tone. Simply, tone is that quality which is measured in degrees on a scale from white to black. The tone of a particular object depends upon two things: its local colour and the amount of light that is falling on it. If things were not coloured, but simply several shades of grey, painting, while being very much less interesting, would be quite a lot easier. The texture of an object plays a part as well: some objects, of course, are matt, others velvety, others shiny, and so on. A dark grey shiny object will reflect more light than the same dark grey in a duller material. I can still remember, many years ago, a tutor pointing out to me that while the lino on the life-room floor was certainly dark brown, consequently much darker than the model, the position from which I was looking at it caused its shiny surface to reflect more than half the light it was receiving. A camera would not have had my knowledge that it was dark lino, so it would have had no problem in recording the tone as it was.

Add colour to texture and the problems are multiplied. Consider the fact that a purple object (purple being a dark colour) in a lot of light can appear lighter than a yellow object (yellow being a light colour) in a lot less light. If you look at a black and white photograph you will see how the registration of light and shade is complicated by the tones of the colours that the photographic process has turned to monochrome.

It is an interesting and useful exercise to look at a scene in front of you (any scene that is not overly complicated), and arrange the tones in ascending or descending order of brightness, assigning the number 0 to white and 10 to black. You can do the same thing with a photograph or a reproduction of a painting.

When you are painting, it often helps initially to separate tone and colour. Look at the sitter and whatever else you are including in the picture and decide which are the lightest and the darkest areas, irrespective of colour. Then, in your mind, arrange the other tones on a scale between. It can also be a good idea to do a tonal drawing or make a monochrome study from time to time. In the past students were required to render certain subjects, particularly antique statuary, in monochrome, almost as though what they were painting was itself without colour, in order to clarify their understanding of the form and structure.

A feeling for tone is especially valuable for the portrait painter, as painting flesh requires a particularly sensitive awareness of small changes of tone. It is a common fault to pitch the tone of flesh too high, so that it looks chalky. Flesh is light, of course, but relatively so (should your model be wearing a white shirt, this will be abundantly clear; if the model is wearing no white, simply hold a piece of white paper against the face – you will see how much darker the flesh is). Again, the tonal gradations found in flesh are very subtle, and in the middle range very close together. The differences in tone between the light and the dark in folds of flesh are on a minute scale compared with different tones in, say, the hair. There is a temptation when you see a fold of flesh to make it too dark, which can destroy the whole tonal balance of a portrait.

Colour

There are many rules of thumb concerning colour and many precise and scientific formulations about the nature of colour and the relationship between the colours themselves. Theories of colour are not an essential part of the artist's repertory of knowledge; a lot of perfectly good, indeed marvellous, pictures have been painted without their help, and too rigid an application of the rules can easily result in a picture which is simply a demonstration of a theory. However, the basic rules are useful, not as something to be consciously applied while actually painting, but as background, guiding information.

Practically everyone knows that a prism divides light up into its constituent hues, and has observed this occurring in the rainbow. The artist also needs to be aware of the relationships between the violet, indigo, blue, green, yellow, orange and red of the spectrum, and to bear in mind the difference between light on the one hand and paint on the other. For example, the colours of the spectrum arranged like segments on a circle will produce white when the circle is revolved at high speed. If you mix those same hues in paint you will produce mud.

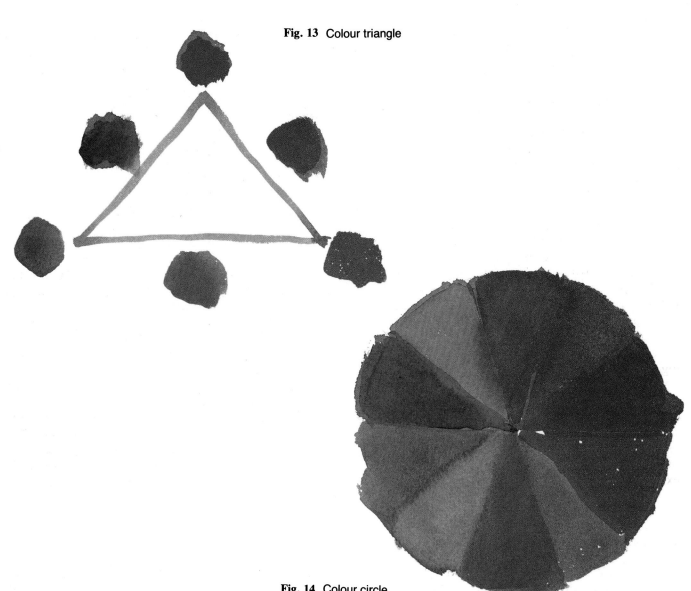

Fig. 13 Colour triangle

Fig. 14 Colour circle

The simplest way of expressing the relationships between the colours and their action on each other is by means of a triangle (**fig. 13**). Make the points of the triangle represent the three primary colours, red, yellow and blue, and the sides of the triangle a mixture of the two primaries at their respective ends. Thus, between red and blue is violet, between blue and yellow is green and between yellow and red is orange. Another, more subtle method of representing these relationships is as a circle (**fig. 14**). Imagine a clock face with red at one o'clock, yellow at five and blue at nine. If you mix red at one o'clock and yellow at five, you will produce orange midway at three o'clock, and so on. The circle gives us a fuller range of hues than the triangle, and on a continuous scale: for example, at two o'clock you have a red-orange and at four, a yellow-orange.

The practical use of this arrangement of colours for the painter lies in the manner in which they act on each other. In both the triangular and the circular form colours opposite one another are called complementary: so, red is the complementary of green, blue the complementary of orange, yellow the complementary of violet, and so on. In theory an equal mixture of complementaries gives white; in fact it gives a variety of coloured greys. But the practical point about the behaviour of complementaries is that they provide the maximum colour contrast. The red of a poppy against a background of grass is reinforced by the green of the grass. The eye is fatigued by concentrations of a particular colour: its ability to perceive that hue lessens, because the hue's complementary tends to become superimposed, and this blunts the original sensation. Test this yourself by looking at a patch of red or a red object for a minute or so, then look away at white paper. You will see on the paper a pale image of the complementary, in this case green.

18

The opposite of contrast in this context is colour harmony. Harmony is produced by selecting a group of colours from the same segment of the circle: for example, nine o'clock to twelve would be one harmony and one o'clock to four would be another.

Perhaps the most satisfactory method of using colour in a composition is to base it on one colour with its surrounding harmonies, offset with small accents of a complementary or near-complementary (see **fig. 15**).

Another general principle is that all colour can be thought of as either warm or cool, though to convert the thought into precise practice can sometimes be difficult: with green, for example, which has a very wide range. In landscape painting distant hills are generally represented as blue – an instance of the rule that warm colours advance and cold colours retire. (Turner utilized this fact by painting many of his watercolours on blue paper – a built-in distance, so to speak.)

Painting must not be thought of as akin to printing, where the primary colours are mixed by printing one over another, with the addition of black to produce the darks. Indeed, it might be a good idea from time to time to exclude black as a darkening agent from your palette – a phthalo blue or Burnt Umber will produce a tone dark enough for most purposes. The black in the tube is not the same experience as, say, a black hat, or a black motor car, or the coat of a black cat, and black horses are another thing altogether. Your model may have what is called black hair, but there is a great difference between the black of hair and the black of paint.

Certainly you should banish the thought of black in connection with shadows. The colour of a shadow is *not* the local colour of the object plus black – try

Fig. 16
Colour in the head

mixing black with yellow to produce a shadow on a lemon, say: the result is a dirty green. While all colour must be carefully observed, the colour in shadows is often crucial. However dark the shadow, there will be some hint of warmth or coolness.

As a portrait painter, you should also forget that you can buy paint labelled 'flesh colour'. Try not to think in such categories. No one is uniformly 'flesh-coloured'. In occidental faces, while some are pale and others reddish or swarthy, there is a general allocation of colour areas that is fairly constant. **Fig. 16** is a schematic representation of areas of colour in the head. You will see that the warm colours are mostly in the centre of the face – as in rosy cheeks – but sometimes across the nose as well; accents of stronger red are often found in the ears, or where the nostrils meet the cheek. The forehead is cooler than the cheeks, sometimes markedly so, except across the eyebrows. The neck is usually tinted towards a pale ochre. On men the area where the beard grows is cool, often a quite positive grey-blue.

Another point – don't be fooled by words. The 'whites' of the eyes, for instance, are seldom white. It is the painter's business to *see* what things actually look like.

And the more you concentrate your gaze on anything the more you will tend to see. But there is yet another danger here. It becomes fatally easy to overdo the changes of colour you perceive in the face you are painting. If such complications occur, look away from the model for a few moments and then look back; you should now be able to see more clearly and simply.

In painting everything is relative. You put one colour down, then a second against it, and the two modify each other. Degas once said that the art of painting was to surround, say, a patch of Venetian Red with other colours, and make it appear vermilion.

In the end, colour in use, whether in a painting or in interior decorations, will be a matter of individual taste. It is impossible to argue the fact that red and green produce the effects they do; how such effects are used in a picture is a matter of infinite argument.

Fig. 15 The colour in this pattern of rectangles is based on the yellow, orange, red part of the spectrum, with the addition of a little burnt umber and crimson. The green accents are in fact touches of blue, which on the yellow appear as green.

19

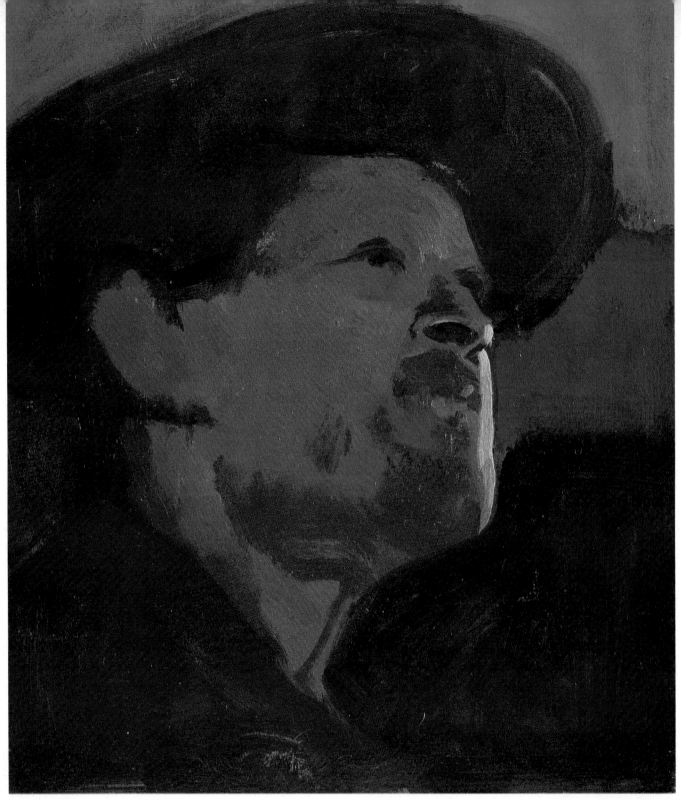

Fig. 17 *Lester Young* 1987 oil on board 30 × 25 cm/12 × 10 in

Lester Young

In my picture of the musician Lester Young (**fig. 17**) it is the light on the face against the dark background that gives the basic form. The head of the subject stands out clearly against the bold, simple shapes of the background colours. Red in the background really seemed to suggest itself: Young's playing is warm and melodious and passionate, and almost without my thinking about it the picture became warm and darkish in tone. When I had put down the red some coolness seemed necessary to counteract it, so I added the blue. The shadows and darker patches in the face are also slightly bluish, picking up the background colour. In choosing these particular colours, I think I must also have had in the back of my mind an image of the colours, lighting and general atmosphere of a jazz club.

COMPOSITION

The basic approach to painting a portrait is the same no matter what medium you are using. Obviously, different mediums tend to result in different sorts of images, but the underlying concerns will be the same. In the following pages I will outline these concerns as they arise in the actual business of painting. I will include hints and observations that are the products of my experience – another artist may well give you a different list.

All painting operates through drawing, colour and tone. Different periods have favoured different proportions of these ingredients, just as different individuals will, as well as different genres of painting. Whatever the ratio, however, while you are actually painting, they are in the air at the same time, like balls or Indian clubs.

From my experience, I would say that the central plank of portraiture is drawing: not drawing for its own sake, but drawing to establish measurement, angles, lengths, changes of direction.

Likenesses result from drawing, that is, the process of drawing which takes place continuously in a painting. The foundation of this kind of drawing is looking hard at the subject. Indeed, the importance of just looking cannot be overemphasized. For example, if you spend an hour painting something, at least fifteen minutes of that hour should be taken up with simply looking, rather than doing. The looking will familiarize you with the subject's over-all characteristics and may cause you to modify the pose and lighting.

Before you start your painting, give some thought to how the model is to sit, bearing in mind that he or she has to be comfortable, and that you need a pose that makes a good shape on the canvas. (If you are painting over several sittings, and if circumstances allow, mark the exact position of the model's chair, and that of the feet.)

Once the pose is decided, the next step is to assess the model's basic proportions. The process of measuring, checking measurements, and taking measurements of increasingly small details, should continue all through the painting.

The traditional way of measuring is to hold your brush up at arm's length and check off distances against the brush-end. Before you start your painting, note the size of the head, and how many times it goes into the amount of body you have showing. (Usually, the head will go into the full-length adult figure about seven and a half times.) Later, you

Fig. 18 *The Artist's Wife* 1982 pencil drawing

will need to check the smaller measurements. For example, measure the width of the shoulder in relation to the length of the head, the height of the forehead in relation to the length of the nose, and so on. Plumb a line through the model from some prominent feature, say the edge of a nostril or the corner of an eye. (Until you have the experience to assess this by eye, use a plumb line. It is very easy to make one – just tie any small weight, such as a bunch of keys, on to a length of black thread.) Note what other features are cut by the line, and rule a corresponding line on the canvas. Keep checking this line throughout the painting, and every now and again plumb other features in the same way.

As well as vertical checks, use your brush handle as a ruler to measure horizontal angles, for example, the angle through the eyes, or through the shoulders. These things are not approximate, neither are they a matter of guesswork.

At the outset, work out which parts of the model are nearest to you, and try to see the head, as it were, in perspective. Decide where on your canvas (or board, or paper, or whatever), the head is to be, and then where the rest of the body will be in relation to it. Have you got room for the hands, or will the edges of the canvas disastrously chop them off at the wrists? Indicate the basic proportions with charcoal.

If you feel quite confident of your composition you can work directly on to the canvas. But you may find that it helps to make a small rough plan in a notebook, or on a bit of paper, first. Draw a rectangle in proportion to the canvas and sketch your plan inside

it. Enlarging a drawing on to a canvas is quite a straightforward affair. Just place the rectangle that frames your sketch on the bottom left-hand corner of your canvas. Draw a diagonal through the rectangle and continue it till you reach the enlargement you want: any pair of vertical and horizontal lines that meet at the diagonal will produce a rectangle in proportion to the original, as shown in **fig. 19a**.

Draw a second diagonal across the canvas, to bisect the first, then draw a vertical and a horizontal line across the centre. The first rectangle is now divided into four smaller rectangles. Draw diagonal lines from corner to corner across each of these. Continue in this way (**fig. 19b**) till the grid is as fine as you require. Number the rectangles if you need to. Indicate on the canvas what occurs in the corresponding rectangle in your plan (**fig. 19c**).

Now take a large brush and block in the main colour areas very broadly, thinking about the look of the canvas as a whole and seeing the colours as shapes. At this stage do not linger on features, do not think about expressions, avoid speculations about the model's nature and psychology. Simply concentrate on the large shapes and the underlying

structure and how they fit together. Sargent said that features bore the same relation to the head as spots do on the skin of an apple. He was exaggerating, of course, but on the side of truth. It is a useful notion to bear in mind.

When you have the basic shapes you can start to tighten up the drawing, but still avoiding details. At this stage you should be refining the shapes, in rather the way you would if you were making a model. If you are making a model you can't start with the features, because you have nothing to put the features on: you have to start with the big shapes. And it is the sense of the big shape that you should carry through your portrait. Amateur painters often get arrested by detail, thinking, perhaps, that that is where the essence of character lies.

When you do start to work on the head in a bit more detail, do not lose sight of the structure and over-all shape of the face. Starting with the eye nearer to you, gradually increase the definition of the features. Watch the tones very carefully at this stage. For example, it is a common fault in inexperienced painters to get the tones under the eyebrows or under the nostrils far too dark. Leave the mouth,

Fig. 19 Enlarging a drawing

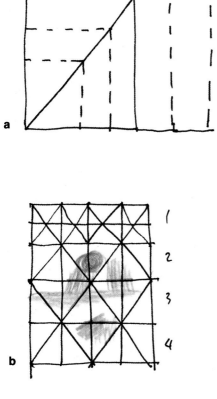

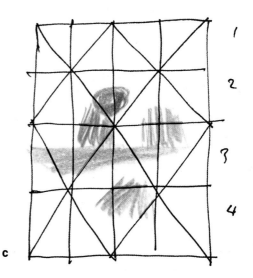

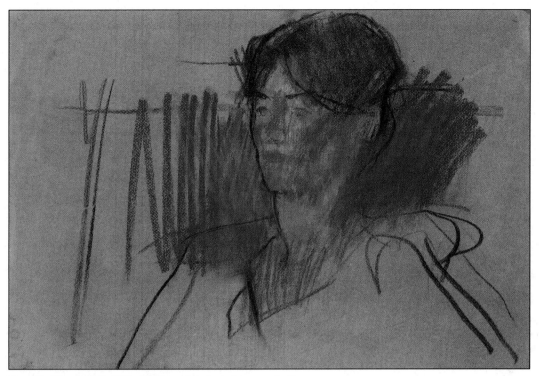

Fig. 20 *The Artist's Wife* 1986 pastel study for a portrait

which is the most mobile feature, till the very end. Expression evolves, and you don't want to fix it too early. One of the worst, most inhibiting things that can happen is to get a satisfactory expression almost by accident and consequently be forced to paint the portrait round it.

If you are sitting to paint, get up every so often and look at the painting from a different viewpoint and from further away. The eye gets used to what it is seeing and the important discrepancies between the picture and the model get lost. Looking from a fresh position will help you to see the picture anew. So, incidentally, will looking at it in a mirror. If you can arrange it so that the image of your painting and that of the model are side by side and the same size in the mirror, so much the better.

Louise

The fact that painting is a business of trial and error is rather painfully illustrated by the progress of this painting – intended, initially, as a straightforward demonstration of technique.

First stage I decided where on the canvas the head was to be, indicated it with a few charcoal lines and very roughly marked in the positions of the arms and hands in relation to it. I made one or two quick

RIGHT **Fig. 21** First stage

23

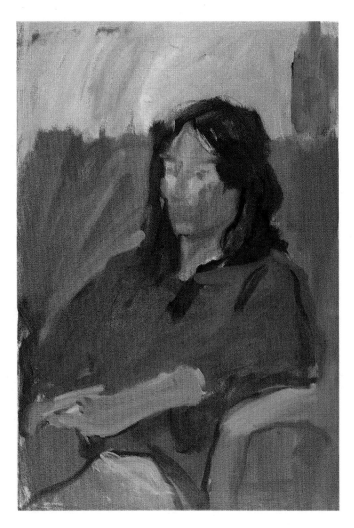
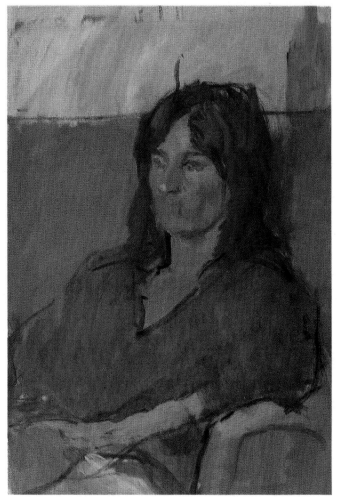

measurements of proportion, checking the distance from the top of the head to the chin and comparing that with the distance between the chin and the forearm. Then I reinforced the charcoal marks (**fig. 21**).

Second stage I then laid in the basic shapes and colours. I put down flesh colour in a flat area to indicate the face and neck, making no attempt at modelling. Against this I set the shape of the hair, the flat shape of the body, the chair, until the canvas was covered. Then I returned to the head and indicated very broadly the position of the eyes, the bottom of the nose, the lips and the bottom of the chin (**fig. 22**).

By this time I was fairly uneasy about the colours. I seldom base colour schemes on contrast, preferring to work with related main colours, accented here and there with contrasts. In this case I had departed from my usual procedure. I had not asked Louise to wear a viridian sweatshirt, she just happened to be wearing it, but I am always attracted by that particular blue-green, and I was happy to use it. The problems had begun when, without thinking hard enough about it, I sat her down in the pink chair in my studio. The strong

contrast between the pink and the green was now definitely beginning to look like a mistake. However, it is very difficult to abandon a painting on which you have expended some labour. As so often, I went on, in the hope that the problem would right itself.

Third stage Starting to measure more precisely now, I marked the planes of the face, the angles of the nose. I noted exactly where the corner of the eye came against the inside of the bridge of the nose. From that point I drew a vertical line in charcoal right through the figure, from the top of the head to the bottom of the canvas. I held my brush up to correspond to the line and checked where it intersected other significant bits of the painting, such as the arm, the neck, and so on. Then I checked the features (for example, the length of the nose) against this line. When I felt that the head was beginning to take shape, I checked the proportions of the other parts of the picture against it. I drew a line to indicate corrections, then painted up to the line (**fig. 23**).

ABOVE LEFT **Fig. 22** Second stage
ABOVE RIGHT **Fig. 23** Third stage

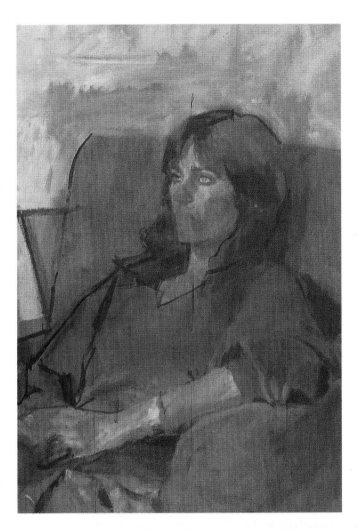

Completed portrait When I got to this point, I was forced to acknowledge that the picture needed drastic rethinking. Far from improving matters, I had been reinforcing a failure. This again is a common experience. When a picture goes wrong in one area it can very quickly go wrong in a lot of others – like panic spreading. Difficulties with composition soon become difficulties of drawing, and the painting as a portrait starts to disintegrate before you eyes. Which is what is happening here, in **fig. 24**. My initial diagnosis of the problem concentrated, wrongly as it turned out, on the colours. I replaced the pink chair with one upholstered in greyish-green, so the colour scheme became a sort of harmony of greens and greys, with the flesh providing the warm tones. However, once I had started to work with colours I actually liked, it became increasingly apparent that the figure did not fit well in the rectangle of the canvas. I also became aware that the light on the figure as a whole, and particularly on the face, was too flat. I finally decided to start from the beginning again, using a canvas of the same size as the one I had used for my first attempt, but turning it on its side, to give landscape proportions. I left the pose more or less the same, but turned the chair away from the light a little, to produce some definite modelling on the figure. I find this second version (**fig. 25**) much more satisfactory than the first.

LEFT **Fig. 24** *Louise* 1988 oil on canvas 76 × 56 cm/30 × 22 in
BELOW **Fig. 25** *Louise* 1988 oil on canvas 56 × 76 cm/22 × 30 in

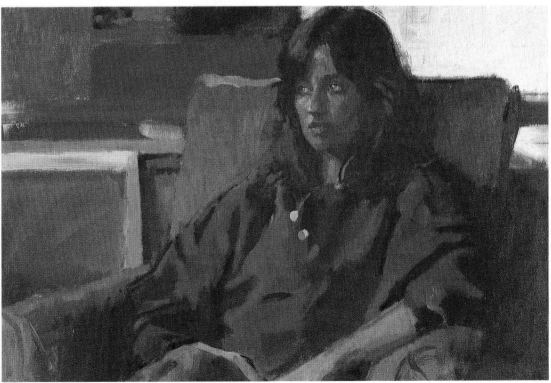

Fig. 26 First stage

Fig. 27
Second stage

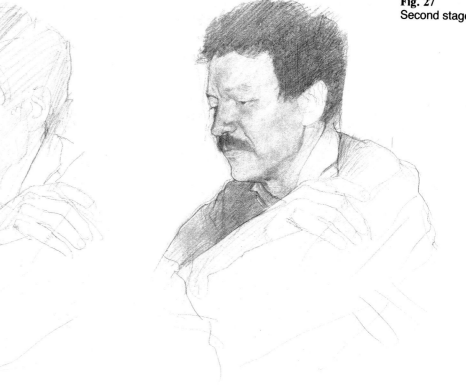

Michael Leonard

Before I paint a portrait I often do exploratory drawings, to test whether the pose is going to work and sometimes as a way of accustoming myself to the model's features and expressions. As in this case, when I come to the portrait itself I often use a completely different pose.

When I start a drawing I like to keep it as fluid and as lively as I can. The degree of finish on drawings such as this seems to be quite arbitrary. I am doing the drawing for information, not for its own sake, so what it looks like is less important than what I learn from it.

First stage The most important thing at this stage is to get to know the subject in terms of basic shapes and proportions. Using a 2B pencil and concentrating entirely on proportion, structure and mass, I marked in the large shapes (**fig. 26**).

Second stage I started to explore the shapes inside the face, for example around the nostrils, using my pencil to produce tone and taking out the highlights with a putty rubber (**fig. 27**). A reasonably heavy paper, such as the 290 gsm (140 lb) HP paper used here, will take quite a lot of rubbing.

When you are painting in oils, if you make an error you can paint it out with solid colour; you can't do this with watercolour. So a watercolour portrait requires more caution than a portrait in oils. The difficulty is that at the same time it demands more confidence and panache, because nothing will kill a watercolour more quickly than an excessively tentative approach. Most people, including myself, are tempted to use washes that are too pale, fearing to apply a wash that is too dark for flesh, and also hoping that, if necessary, it will be possible to put on darker washes later. In fact the tone of flesh is usually darker than you think. And if you are going to err, it is better to put on a wash that is too dark than one that is too light. You can sponge off a dark wash while it is still damp, but if you apply too many washes, in series, the picture will lose all spontaneity, and the surface will look tired.

But it will help you to avoid difficulties in determining tone if you establish as early as possible which is the lightest or the darkest area you are going to paint.

Third stage First I marked in the general shape, just marking rough indications in pencil. I did not rub out these pencil lines – rubbing roughs up the paper, and then the wash will go on badly. Most pencil lines disappear under a wash, even a pale wash. The next step is to look for the darkest or the lightest area, to establish a key for the tones. The darkest areas here were clearly Michael's hair and the dark navy jacket he was wearing (**fig. 28**).

Fig. 28 Third stage

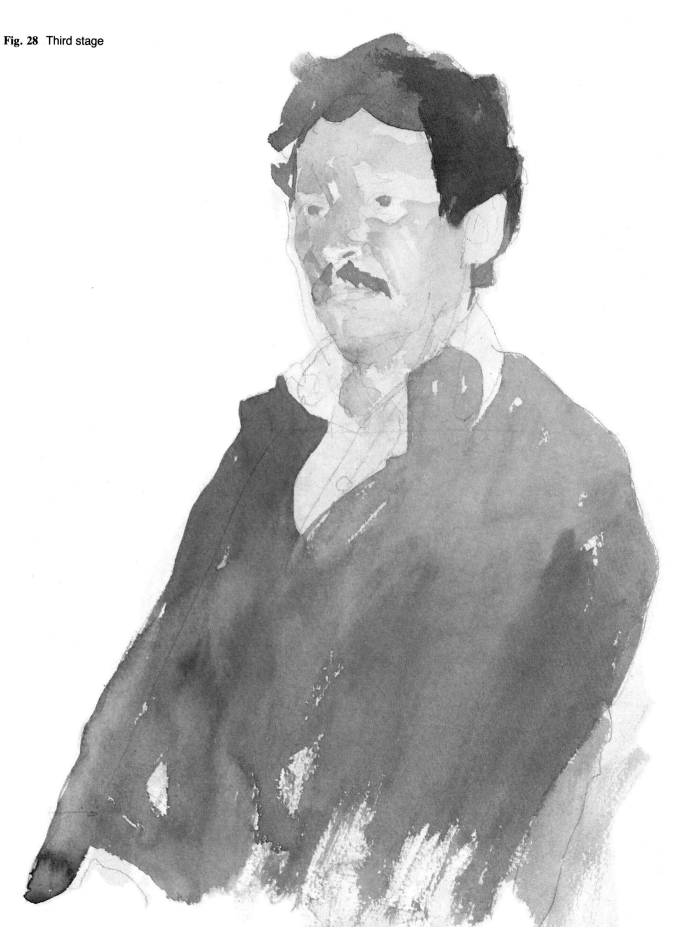

Fig. 29 Fourth stage

Fourth stage At this stage I began working with more precision, adding colour and shape at the same time. It is important to work all over the picture, not just on the head – remember, all the tones are relative.

Fig. 30 *Michael Leonard* 1986
watercolour 36 × 27 cm/14 × 10½ in

Completed portrait At the final stage I worked with an almost dry brush (a fair-sized brush, a number 5 or 6, but with a fine point), building up the details in terms of structure. Here I was very conscious of the edge of the nasal bone, and the high cheekbones.

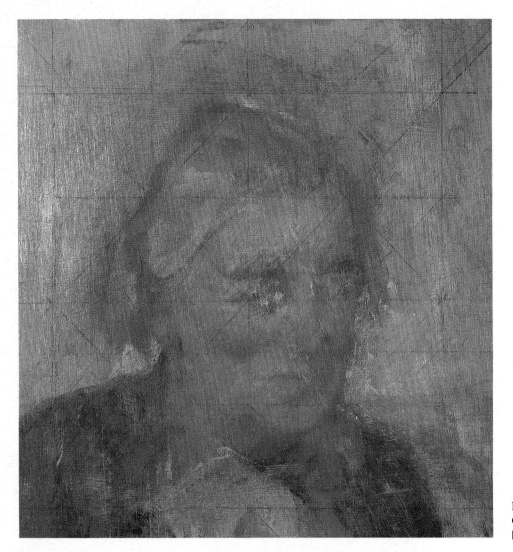

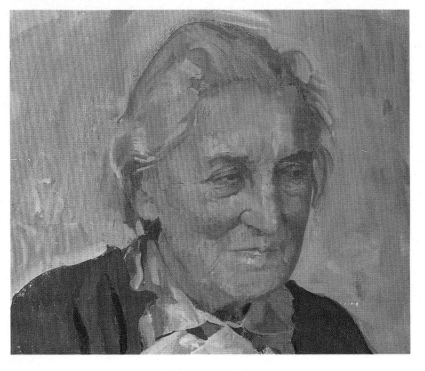

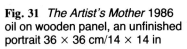
Fig. 31 *The Artist's Mother* 1986 oil on wooden panel, an unfinished portrait 36 × 36 cm/14 × 14 in

Fig. 32 *The Artist's Mother* 1986 oil on wooden panel 25 × 30 cm/10 × 12 in

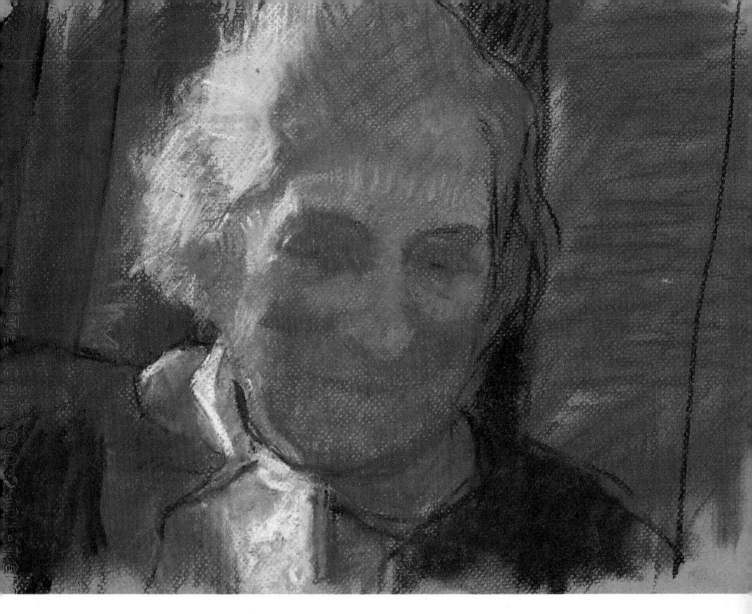

The Artist's Mother

Fig. 33 *The Artist's Mother* 1986 pastel 28 × 38 cm/11 × 15 in

Fig. 31 shows a first attempt at a portrait of my mother. I abandoned it because I wanted the head to fill more of the board. The first panel I chose was too large in itself, so if I had done the portrait in the proportions I wanted the head would have been too big. Also, at that time I didn't like the way the painting was going. Now I feel that, unfinished as it is, it has a kind of simplicity which perhaps the finished oil lacks. This second oil (**fig. 32**) is a reasonably accurate likeness, I suppose, but personally I find it a bit dull.

The pastel shown in **fig. 33** was done half-way through the painting of the second oil. I was getting too niggling and obsessed with details, and needed a fresh perspective. The change of medium (pastel is of its nature a broader medium than oil) and use of a different pose made it much easier to see the essential character and nature of the face. Also, the fact that the side of the face is lit and the features are in shadow gives a more immediate sense of solidity.

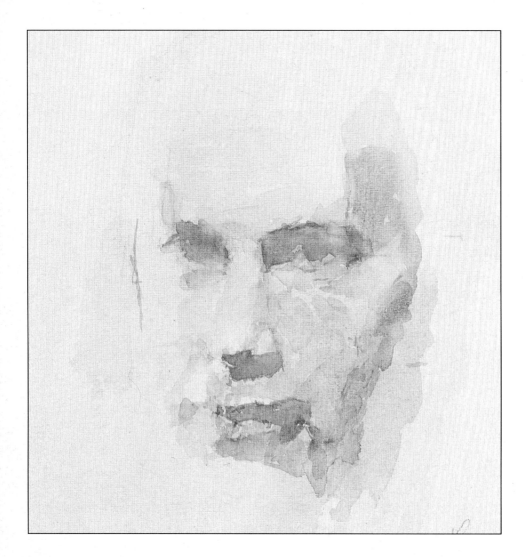

Prokofiev studies

And when is a portrait completed? It is hard to know, sometimes. Completeness is an intangible quality, very difficult to describe. I would make a distinction here between completeness and finish. You can have a very detailed, very 'finished' painting which yet seems incomplete because the composition is not satisfying. On the other hand, you can have a very sketchy work which is, somehow, complete. If a portrait is properly composed you can stop it, as it were, at a particular level, when all the parts are right in relation to each other.

I painted these studies (**figs. 34** and **35**) of Prokofiev (from photographs) after listening to his *Visions fugitives*. I love Prokofiev's music, and I wanted to do a picture which in some way reflected my admiration. When I started I didn't know quite what I was going to do, except that I didn't want to do a straight academic portrait. I stopped both these studies at a fairly early stage: it seemed to me that they had a certain completeness at that point. I started other, more conventional, portraits, but abandoned them.

ABOVE **Fig. 34** *Prokofiev* 1978 watercolour 30 × 30 cm/ 12 × 12 in
RIGHT **Fig. 35** *Prokofiev* 1978 watercolour 21 × 33 cm/ 8½ × 13 in.

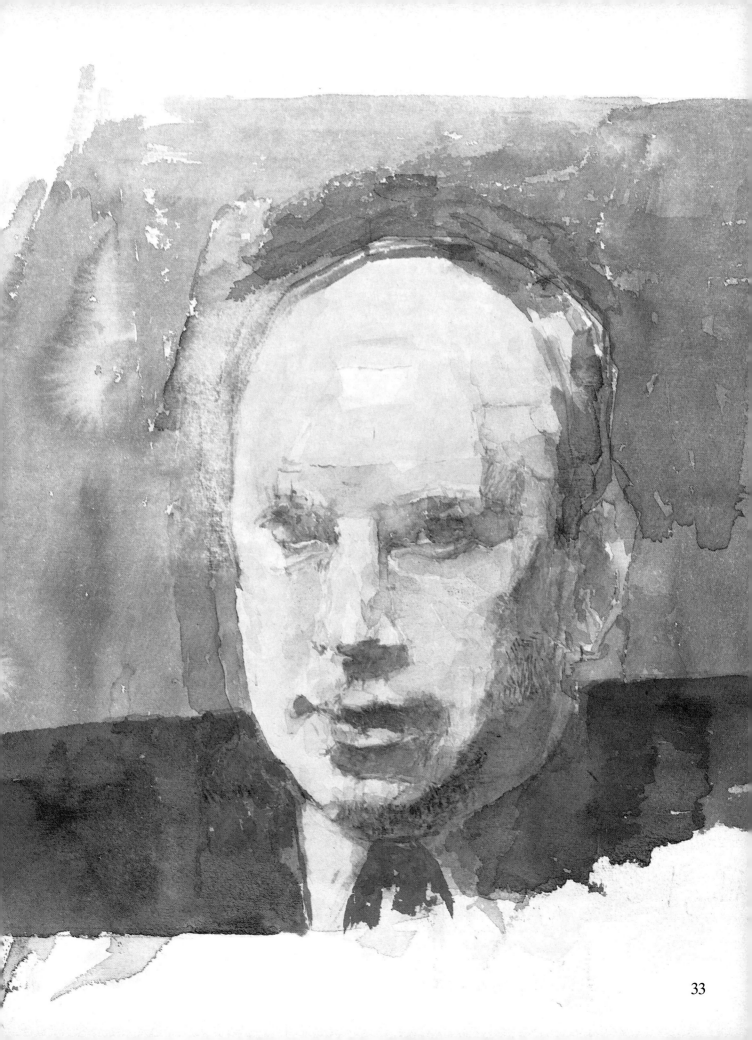

VARIOUS MEDIUMS

Choice of medium is by no means always a rational matter. For instance, I did not use watercolour for years, for no better reason than that I could not imagine myself using it. Perhaps this was simply because the physical substance of oil paint has always appealed to me so much.

I would not recommend any student of painting to switch methodically from medium to medium just for the sake of experience. It is preferable to get some kind of confidence with one medium and then move into other areas as the mood takes you. Your choice of medium can depend, of course, on the kind of subject that attracts you: for example, if you want to paint a landscape, watercolour could well be your first choice as a medium. A portrait, on the other hand, usually suggests oil or acrylic – anyway, a 'solid' medium where adjustments can be made throughout the course of painting.

A change of medium forces a change of tactics, or it ought to. You cannot produce the same kind of image in, for example, pastel as you can in watercolour. You are in a sense in partnership with the medium – it affects what you do, even how you see, as you attempt to give an image shape and coherence.

The six paintings in **figs. 36–41** are all versions of the same portrait, each done in a different medium. They illustrate fairly clearly the characteristics of the various mediums, as well as how different mediums seem to lead to different interpretations of the subject. This latter point underlines the principle that there is no such thing as one 'right' likeness.

For example, with a portrait in line, the size of the image is going to be very much related to the thickness of the line: if you are using an instrument that produces a fine line, the image cannot be very large, or the line would become meaningless. For this reason, the image in a pen or pencil drawing tends to be small. A brush, on the other hand, produces a big, bold line: consequently, the image in a brush drawing will be bold. Oil paint allows a great variety of treatments, from sketchy to highly finished, whereas, because it permits only limited correction, watercolour tends to invite spontaneity and informality. With oils or watercolours colours are mixed

Fig. 36 Pencil

Fig. 37 Pen and ink

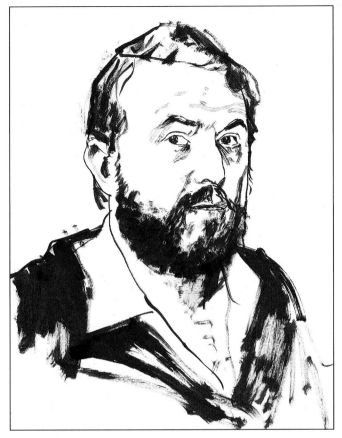

Fig. 38 Brush drawing

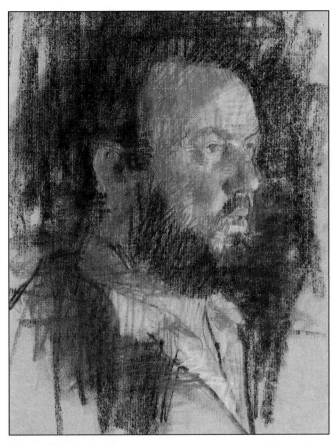

Fig. 40 Pastel

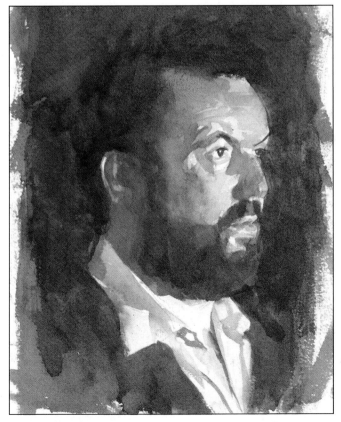

Fig. 39 Watercolour

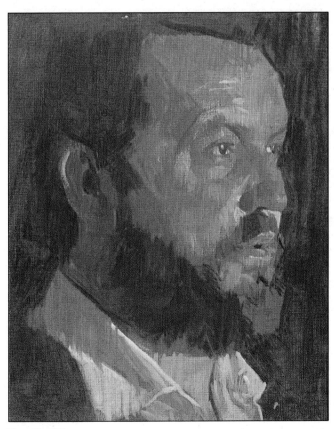

Fig. 41 Oil

on the palette; but with pastels, the colours are mixed on the paper itself, one colour being superimposed over another. And often, as here, using pastels leads to richer, sometimes brighter, colour.

In short, the medium the painter uses will require him to select different aspects of his subject for emphasis, and to minimize or exclude others.

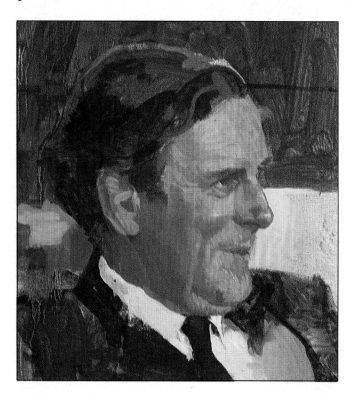

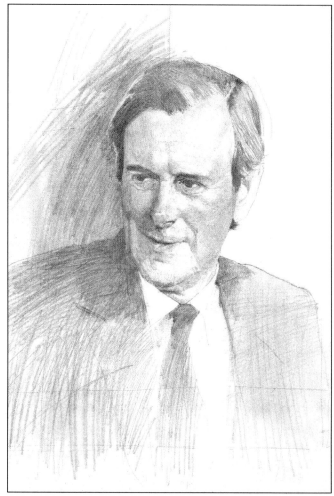

ABOVE **Fig. 42** *David Skeggs* 1986 oil on wooden panel 30 × 25 cm/12 × 10 in
ABOVE RIGHT **Fig. 43** *David Skeggs* 1982 pencil study for portrait
RIGHT **Fig. 44** *David Skeggs* 1982 oil on paper 30 × 36 cm/12 × 14 in

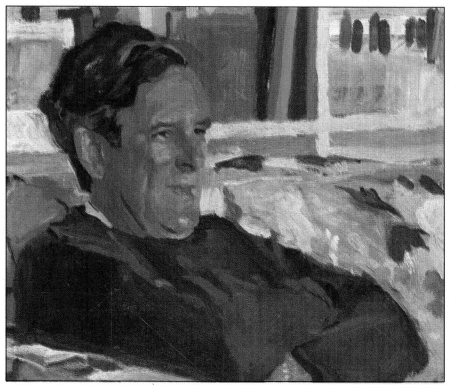

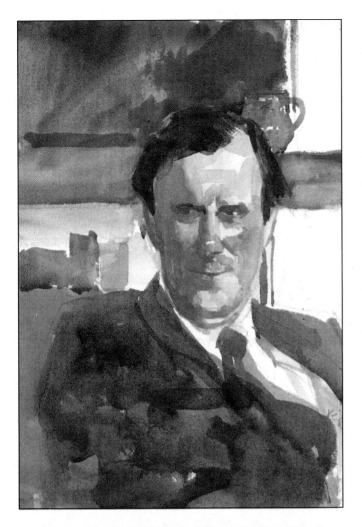

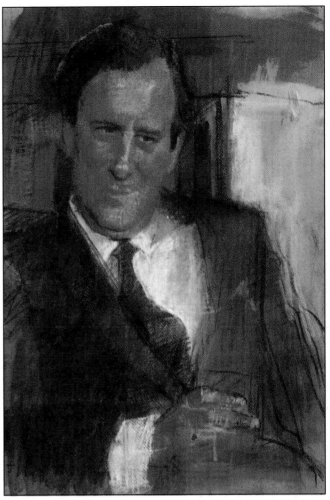

ABOVE LEFT **Fig. 45** *David
Skeggs* 1985 watercolour
study for portrait
ABOVE **Fig. 46** *David Skeggs*
1986 pastel 55 × 37 cm/
21½ × 14½ in
LEFT **Fig. 47** *David Skeggs*
1986 pastel 35 × 50 cm/
13¾ × 20 in

THE USE OF PHOTOGRAPHY

Photography, after terrifying painters at its invention in the middle of the last century, has now been more or less accommodated by them, and may certainly influence what they produce. In one sense the whole development of modern art can be seen as a consequence of the camera's usurping the painter's principal, traditional role as a reporter of what things look like, allowing him to wander along more irrational and more decorative paths.

More directly, many painters have used photographs as a basis for paintings. The exponents of Pop Art, of course, are famous for using photographs, often taken from newspapers and magazines. Pop Art painters frequently emphasize the 'photographic' qualities of the photograph – distortions, for example, created by accidents of light and movement or the peculiarities of the lens. Other artists, among them the painters known as Photo-Realists, simply use the photograph as a thing in itself and render it, edge to edge, on a large scale. Most painters, some aware, some unaware of the camera's idiosyncrasies, simply use photographs as a short cut, or for convenience: nature at one remove, as it were. But in the last analysis it is not why but how photography is used that counts. The finished painting is proof of the efficacy, or otherwise, of the method.

More portraits are painted with the aid of photographs than you would imagine, and have been for far longer than is generally reckoned. For example, there is clear evidence that some of the Impressionists, and before them Ingres and Delacroix, used photographs. Some people have raised moral objections to such procedures, implying that only in the presence of the model can any kind of genuine response be sparked. It is certainly true that it is always better to have a model in front of you: somehow the presence of a living model allows you the freedom to use your imagination, while a photograph tends to tie you to its image. But it is often simply impossible to have your sitter always present. Certainly the important men painted by the Old Masters did not sit around in artists' studios for months, or days. Holbein's portraits, for example, were almost always painted from drawings, done in a relatively short time from the sitter. Indeed, it is said that Holbein would draw with paint on a glass placed between himself and the sitter, with a fixed eye-piece to look through to stop the image appearing to jog about, and take a 'print' from the glass to form the basis of his composition. Vermeer used a *camera obscura* – a device which projected an inverted image of the subject on to a ground glass screen from which the salient features could be traced off.

To professional artists, including portrait painters, the camera offers convenience and speed, both great advantages; but such advantages have to be paid for. The first point to be borne in mind, when using a photograph as the basis for a painting, is that a photograph is already a pictorial statement: it has qualities of its own. Sometimes these will be accidental, sometimes the fruits of conscious deliberation. Either way, all photographs are at one remove from reality: they constitute the representation of three dimensions on a flat surface, as does painting itself. Photography is often invoked as a standard by which the objectivity of a representation can be judged – 'It's just like a photograph', people say, intending to praise a painting's fidelity to nature. Most photographs, however, present a very schematic and distorted way of dealing with reality.

Among the factors that influence the character of photographs are, first of all, the subject, then the lens, the speed of the film, the lighting conditions, the method of processing, the experience of the photographer, and the relations between all these. For example, if you take a photograph of a landscape with a range of low hills, say two miles distant, using a camera fitted with a standard lens, it will appear strikingly different from your perception of the landscape itself. The hills will dwindle to an insignificant strip apparently many miles away.

With a closer subject, as in a portrait, equivalent distortions can occur. The features nearest to the lens, usually the nose, become enlarged out of all proportion to the rest of the face – not a reliable basis for painting a likeness.

Another characteristic of photography that can be a disadvantage in a source of reference is its way with tones. Tones similar in degree become amalgamated: at the top end of the scale this means that light areas tend to bleed into an undifferentiated patch containing little or no information. The loss in these situations of the actual highlights is serious, for they indicate exactly where a form changes direction, and the forehead, say, or the nose, is reduced to a smear of off-white. At the opposite end of the scale the same thing occurs. Objects in shadow and dark objects, in shadow or not, lose definition and melt together in large, impenetrable areas of dark. As a further consequence of all this, transitions from light

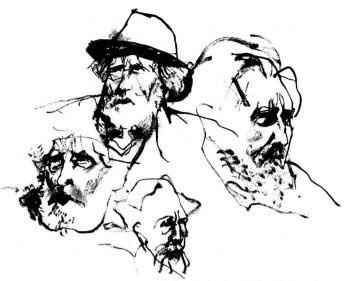

Fig. 48 Studies for a portrait of Ezra Pound 1984 brush drawing

to dark become abrupt and unsubtle compared with the nuances available from nature. Half-tones are very important to the painter, as are the characteristics of forms in shadows, and he is not well served by the camera here.

Of course, there have been times when painters have been able actually to use the kind of simplification forced on them by the use of photography. Manet, in his revolt against the academic procedures of his day, used such effects with great aplomb. Walter Sickert was another painter who used the distortions inherent in photography in his paintings. (It was Sickert, however, who recommended that only those artists who can do without them should use photographs.)

Again, we must remember that the camera, being a mechanical device, has no judgement. It is as though we all possess some kind of filing system modified by experience, in which is contained a sort of master set of acceptable likenesses of people whose faces we know; and that we unconsciously reject those moments when some involuntary gesture, say sneezing, deforms the familiar features. The camera has no such value system, and is able, into the bargain, to record at fractions of a second. Consequently, it can produce sadly or comically bad likenesses of people. It is perfectly possible for an experienced photographer to expose many rolls of film in a portrait session and get only one or two reasonable pictures.

Flash photography produces its own special version of reality. In a photograph taken with the aid of a flash there will be an even, flattish light on the subject, with small, dark shadows at the edges of forms, strong highlights in the middle of a dark iris, and a black background, hardly natural and very characteristic of its kind.

The special usefulness of colour photography is that objects tend to be defined by their local colour, accurate or not, thus giving us more information. But it must be remembered that the colour on offer is only one of a number of possible versions. Had the sun come out, or gone in, when the shutter clicked, had the processor been different, had you pointed the camera up or down slightly, the colour would have turned out differently.

Any artist using photography in his work ought, at the very least, to be aware of its basic characteristics. Better still, he should take the photographs himself rather than depend on those of others. A 'found' photograph does not provide you with much information outside itself; you do not know how accurate an interpretation it is (unless, of course, you have a separate knowledge of the subject). If you take your own photographs your awareness of the circumstances pertaining to but not included in the photograph will be greater. Also, you can try to avoid some of the more obvious pitfalls at the outset.

Whether you are taking or choosing a photograph to be used as the basis for a portrait, the requirements are the same. The lighting should be simple and definite, not diffused, nor coming from different directions with useless reflected lights. Remember, the object is to make the shape of the head and the relationship of the features clear and immediate and straightforward in design. Ensure, by asking yourself questions and making thumbnail sketches, that the photograph you intend to use is, in fact, usable. Often, what appears at the outset to be adequate turns out, after some hours of work, to be much less than satisfactory.

If you are choosing photographs of, say, the great and famous from magazines, avoid on principle pictures by star photographers. The qualities of a painting based on such a photograph are likely to come from the photographer rather than from you.

At the other end of the scale, family snaps can be an equally dangerous source of information. Be wary of arbitrary light, strangely caught expressions, cut-off feet, eyes squinting into the sun, and similar effects! But, having said that, even quite poor photographs can be useful if they are carefully scrutinized and considered before painting begins. Many things happen by accident in photography which can be a useful source of inspiration for the artist.

To sum up: do not be tricked into thinking that photographs are generally 'correct' renditions of the world. Be aware of the differences between your own natural vision and the camera's version, and do not 'copy' a photograph tone for tone, but use it for information. Sense the underlying structure, and interpret what the gradations of tone mean in terms of real flesh and bone.

39

Katie and her Godmother

I took the photograph of my daughter Katie with her godmother (**fig. 49**) at her christening. I came across it several years later, at a time when I was interested in the idea of painting a portrait of a baby, and used it as the basis for the portrait (**fig. 50**).

I tried to use the photograph, rather than copy it. You can see how I edited out the figure in the background, and reduced the whole area to concentrate on the relationship between the two heads. I interpreted the pattern on the dress in a pictorial rather than a literal way, using the actual print as an excuse to invent a decorative pattern that works in terms of the painting.

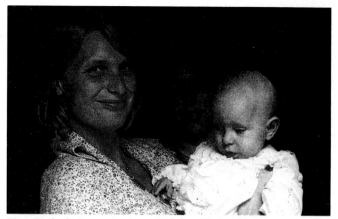

Fig. 49 A photograph of my daughter Katie with her godmother, at her christening, 1975

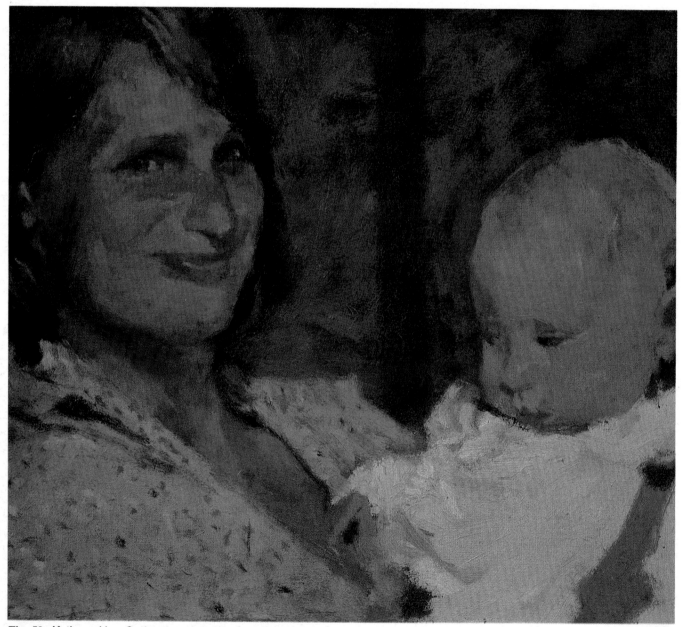

Fig. 50 *Katie and her Godmother* 1980 oil on wooden panel 30 × 36 cm/12 × 14 in

Olivier Messiaen

The immediate inspiration for this portrait (**fig. 51**) was a badly reproduced black and white photograph in a magazine. For some time I had at the back of my mind the idea of painting a picture of the composer, as a gift for a friend who shares my passion for the music of Messiaen. But I didn't actually start to paint until I happened to see the photograph, and was fascinated by the pattern of abstract shapes against the bleached-out background.

Fig. 51 *Olivier Messiaen* 1969 watercolour
48 × 33 cm/19 × 13 in

WHAT CAN GO WRONG ?

A painting may go wrong because of the subject, or the composition, or the drawing, or the colour, or the tone values, singly or in any combination. As well as these technical problems there are psychological difficulties which can lead to various blockages and strange notions, which in turn lead to all kinds of odd things happening on the canvas. But these psychological problems are very individual and need to be sorted out individually. I can only deal here with the technical problems that are most likely to occur in the process of painting a portrait.

Errors in painting from nature can result from, on the one hand, cursory observation, or, on the other, inexpert handling of the picture itself, or from a combination of the two. The first can be corrected at the outset by making diligent observation a habit; the second, of course, is corrected by experience itself. Experience, however, can be assisted.

Composition

Very often students pay too little attention to composition in portrait painting. They seem to feel that if the likeness is all right the rest of the painting does not matter. This is not so. Even if there is nothing else in the painting than the head and neck, as in many Old Masters, the positioning of the head in relation to the size and proportions of the canvas is very important. And you can easily get the head in the wrong place. Of course the 'wrong place' is in the end a matter of judgement and taste – what to one person is an interesting or intriguing placement, to another will seem simply perverse. However, what I would advocate for the student is a responsible and moderate approach.

Some examples of unsatisfactory positioning are illustrated in **fig. 52**. In **fig. 52a** the head looks as if it is being compressed by the top edge of the canvas, and the main area of the canvas is without significant incident. Also, the figure is symmetrically arranged on a central vertical axis. In **fig. 52b** symmetry is avoided, which is basically a good idea, but the means of avoidance are too violent. Unless you are very sure of what you are doing, it is wiser not to crop bits off the head. In **fig. 52c** the effect of placing the head at the bottom of the canvas is nearly comical. The positioning of the head is also too symmetrical. And remember that if you wish to use the head alone, the canvas ought not to be too big in relation to the size of the head.

Drawing

In this context I mean not drawing for its own sake, but those aspects of portrait painting that involve drawing in some form or other. Drawing is the skeleton, the framework of a portrait, and generally when something goes wrong with the likeness it is the drawing that is at fault.

Faulty drawing can result from insufficient observation, not looking hard enough at what is being drawn and not looking at the whole while drawing. For example, if you are drawing the nose, do not keep the eyes riveted on that: look at it, assess its shape, colour, and so on, but then look at the head as a whole.

By far the biggest problem students face is the business of relating the features to the head as a whole shape, set upon the neck and shoulders. It is probably human nature to concentrate our attention on the features: when children, for instance, draw a 'portrait' they tend to group eyes, nose and mouth more or less in the natural order, but to show no interest in the shape, proportion or size of the head itself. The human face is such a powerful image that we can assemble it from the scantiest of clues. But, as students of portrait painting, it is precisely this we have to unlearn; to the portrait painter likenesses are not simply the sum of a collection of features.

So, keep relating one part to another. Do not guess at things like the angle of the shoulders or the depth of the forehead; measure them in the old-fashioned way – arm extended, checking the distances off against the brush-end. Measure, too, proportions within the whole figure, as described on page 21. With experience, the basic proportions can be gauged by eye, almost unconsciously, but however adept you get they still need to be checked and corrections made throughout the painting.

Colour and tone

Drawing is a matter of quantity, that is, a lot of it is to do with measuring – an angle is either acute or obtuse, for example. Colour, of course, is not like this: it tends to be a matter of quality; and of personal taste. It is impossible to know whether or not two people looking at a colour are in fact seeing the same colour.

Problems with colour and tone in portraiture run along a few well-worn grooves. (It can be comforting

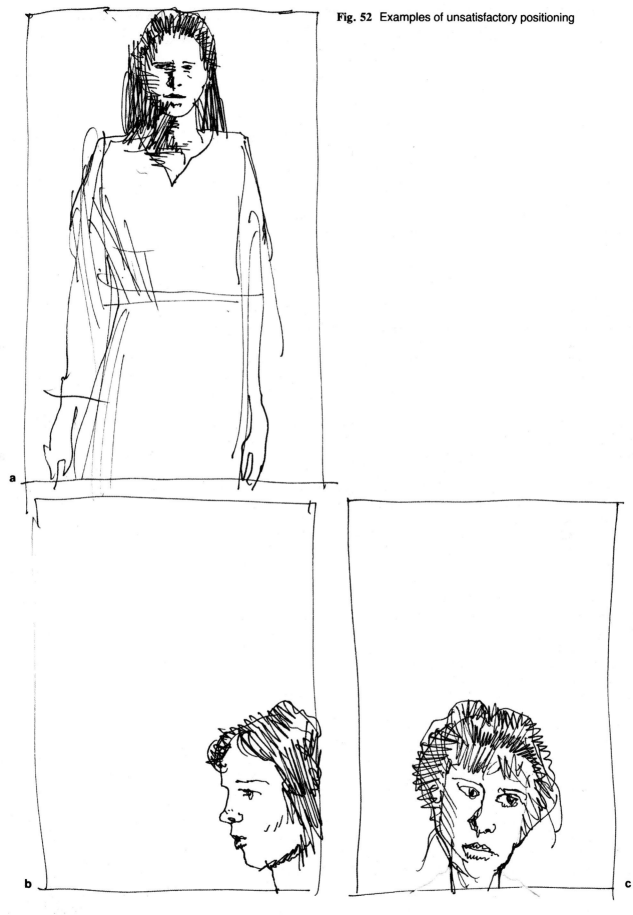

Fig. 52 Examples of unsatisfactory positioning

a

b

c

43

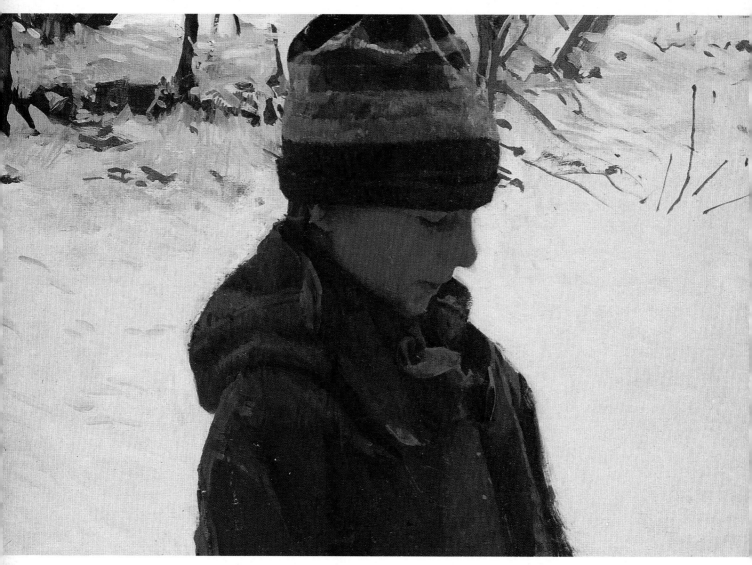

Fig. 53 *Katie in the Snow* 1986 oil on board 20 × 25 cm/8 × 10 in. I always find figures in snow exciting – both visually and because of the echoes of childhood. Flesh against snow looks very rich. But it was the hat, as much as anything, that made me paint this picture.

to remember that the mess you are in has claimed practically all artists at some point in their careers, however good they might be.) Here I will comment on the most fundamental and debilitating ones. These come in pairs of opposites, simply expressed as too little or too much colour and too high or too low tone.

An anaemic, tentative painting is sometimes simply the reflection of a general want of confidence, but sometimes it is the consequence of indifferent observation. In this second case, more careful observation will help it into life. In the occidental human head, warm and cool tints are contrasted (see **fig. 16**). But if the light parts of a picture get too light, they tend to merge in an unnatural, undifferentiated pinkish-white tint, as if the model's complexion were that of a plastic doll. Dark parts too can easily become uniform and monochrome, especially if too

much black is used: remember that shadows are coloured.

At the opposite end of the scale, too much colour can impair both the design of the painting and the clarity of the actual portrait. The problem is that the more you look the more colour changes you will see in the model. To get this kind of confusion under control, you must institute some comparative scrutiny. That is, you have to compare one passage of colour on the model with another, and put your conclusions into words. For example, you might feel that a particular area of the face is quite warm, with a fair amount of red in it. However, when you compare it with another part, say across the cheeks, it may seem hardly red at all.

Tone and colour are, as we have seen (pages 17–20), closely related; and an error in one can lead to an error in the other. For instance, if the tone of a

44

Fig. 54 Studies of heads 1986 pen and ink

painting is too high, the colour will be driven out for the sake of achieving light tones. In a portrait, this will inevitably mean that flesh looks unpleasantly chalky. Moreover, you will find that you run out of light, so to speak: a situation that will become apparent when you are faced with a bright highlight or a white shirt.

Spend some time in deciding just what tone the flesh is – it is usually darker than you at first imagine. And do not think of light as white pigment.

Similarly, too dark a picture will obviously drive out colour, as it will tend to invite black as the darkening agent, and local colour plus black is not the way low tones are best achieved.

On the subject of shadows, remember that unless the illumination is concentrated and intense, the shadow side of the face will be much lighter than the shadow side of a business suit, for instance.

Mouths

Finally, a lot can go wrong with the mouth. Indeed, Sargent described a portrait as a likeness in which something is wrong with the mouth. It goes wrong simply because the mouth is the most mobile part of the face. In the faces we know, we are aware of a repertory of expressions, and in our notion of that face, our mind's eye portrait of it, the expression tends to be unfocused, an amalgam of all the expressions we can recall. Specific expressions, such as misery or (*pace* Frans Hals) laughter, are to be avoided, because they tend to become boring to look at. Usually, in a good portrait the expression is ambiguous – think of the *Mona Lisa*! Forget all notions of characterization or psychology, allow the mouth to evolve, and try to create a likeness without drawing too much attention to it.

EXTENDING THE TRADITIONAL PORTRAIT

A portrait should be more than a good likeness. It is possible to have a good likeness in a bad picture, just as it is possible to have a good picture which is an indifferent likeness. The problem of portrait painting is to incorporate a good likeness into a good picture.

It is said that painting consists of two quite separate elements, the 'what' and the 'how' – the 'what' being the subject and the 'how' the design and execution. It is also said that artists are more interested in the 'how' and laymen more interested in the 'what'. Like all generalizations, this statement is over-simplified; but it does contain an important point, which applies in a rather special way to portraits. I, for example, have on occasions been so excited by the pictorial qualities of a painting – drawing, composition, the handling of paint, that kind of thing – that it has not

occurred to me to consider the subject consciously at all, beyond perhaps noting that the picture is a landscape, or a figure, or what have you. If I walk into a room containing pictures that I have not seen before, after looking around I would always examine first the painting whose pattern quality, if you like, its abstract character, I found the most immediately

BELOW **Fig. 55** *Hannah and Daisy* 1985 watercolour 28 × 38 cm/11 × 15 in. The picture is intended to be a portrait of the dog as well as of the child – though my attention was first caught by how Hannah looked at a moment when she was sulking, and wearing a cap of mine. I have always liked painting subjects against the light.
OPPOSITE **Fig. 56** *Hannah* 1984 watercolour 38 × 28 cm/15 × 11 in

46

appealing, regardless of whether the painting was a landscape, or a figure, or a still-life. Someone whose prime interest was the subject-matter, however, might say, 'Oh dear, still-life there, another still-life here, and a street scene, no – ah, there's a landscape, and a river too' – and investigate further only those paintings with subjects that appealed to him.

Some subjects, particularly landscape, are full of associations, memories of other times, notions of the past or of unvisited places. This goes far to explain the universal popularity of landscape painting as a genre. Compared with such riches, the portrait as a category comes off rather badly. It does, indeed, partake of what is, in general terms, perhaps the most fascinating subject of all, the human face. But the fact remains that the subject of any particular portrait is likely to be of interest only when the spectator knows the sitter, either personally or by repute. Any interest beyond that must come from the 'how'. And here the genre of portrait painting has been painfully limited. If you think again of the ranks of faces decorating the walls of stately homes, the limitations of the repertory of composition in the traditional portrait will quickly become evident. Throughout the heyday of portrait painting the choice available to portrait painters was confined to three or four poses: head and shoulders; half-length with hands clasped or with one hand delicately supporting the chin; and full-length; all against a dark, un-particularized background. Whichever pose was adopted, the attention was concentrated on the head, frequently to the detriment of the figure as a whole. (Often, bodies were painted from draped dummies, and hands were painted from stand-ins, or generalized to the point of formula.) Of course, the tradition of portrait painting has produced many surpassing works, alongside the more humble, the honest, and the dull. The intrinsic qualities of a portrait by Van Dyck, for instance, or Gainsborough, are obvious almost at a glance: in these portraits the 'how' has become more important than the 'what'. But most people find it difficult to respond to the general run of portraits with anything much more than bored admiration – unless, indeed, they are related to, or have a special interest in, the sitter.

Many portraits painted at the end of the last century hint at an impatience with the traditional layout. Looking, for example, at the marvellous portraits of Degas, you can see him working his way out of an exhausted form. Today the traditional portrait, except in the most distinguished hands, tends to be something of a cliché.

I would like my portraits to work as pictures in their own right, and I often find it easier to achieve this if I move away from the traditional format, and introduce other elements.

Fig. 57 *The Artist's Wife at Sandwich* 1986 watercolour study for a painting. I started to paint this picture simply because I liked the figure walking on wet sand, and I developed it into a portrait (albeit without features) as I worked. It is also a portrait of a landscape, at Pegwell Bay – the subject of a Pre-Raphaelite painting by William Dyce which I have loved as long as I can remember.

Figures in a landscape

In portraits I have painted of my two daughters, for example, I have got progressively further away from them, and included more background. This of course means that the figures of the girls themselves become smaller, in some cases very small indeed. Obviously, in such pictures the faces, usually the focal point of a portrait, become less capable of showing detail. Consequently, the body as a whole becomes the subject of the portrait. Since we, in the twentieth century, know how much not only our faces but our whole bodies are governed by our minds, a portrait of a body seems not so very unusual. It is not only the face which is distinctive. You can always recognize someone you know well from a distance, long before it is possible to distinguish the features. Everyone has his or her own way of standing, or sitting. And the masses, the big shapes, of the head, or the neck, for instance, are quite distinctive.

OPPOSITE **Fig. 58** Compositional studies for *Children with Coke* and *The Fence* 1986 pencil and pen and ink
BELOW **Fig. 59** Study for *Children with Coke* 1986 watercolour

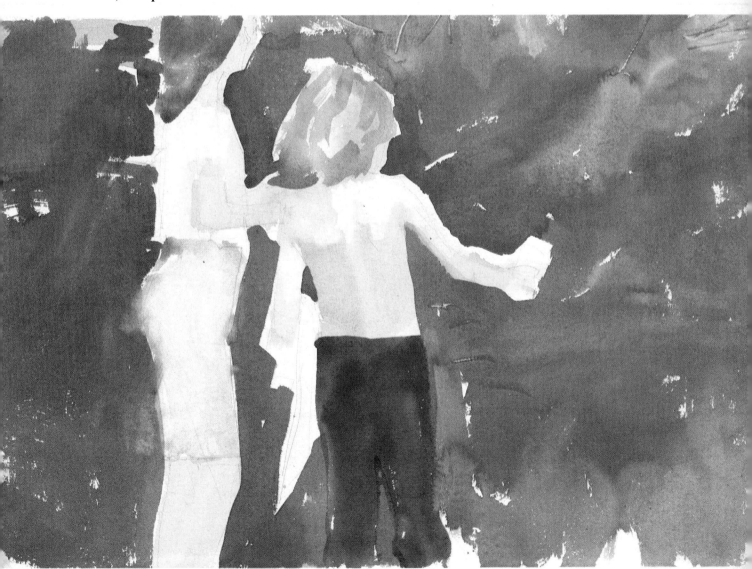

Fig. 60 *Children with Coke* 1986 oil on board
25 × 30 cm/10 × 12 in. I like to see how much of
a likeness I can get without portraying the
features in an obvious way. 'Figures in a
landscape' is a traditional theme. The landscape
here is that around the village where I live. The
actual situation arose while we were out walking:
a friend had given the girls cans of Coke, and the
red tins looked marvellous against the green of
the downs.

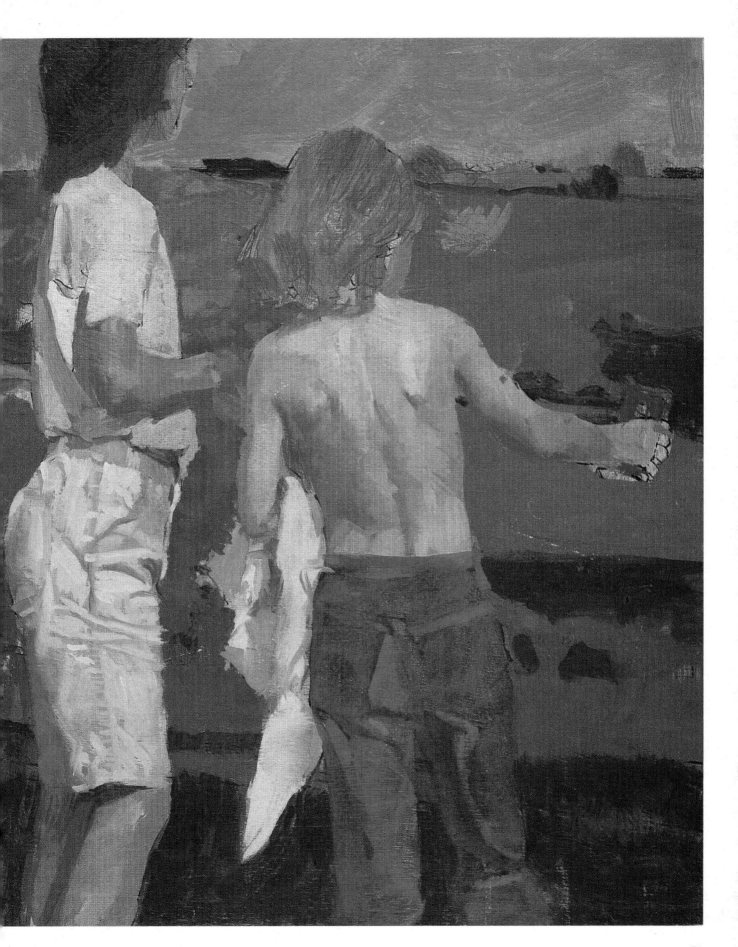

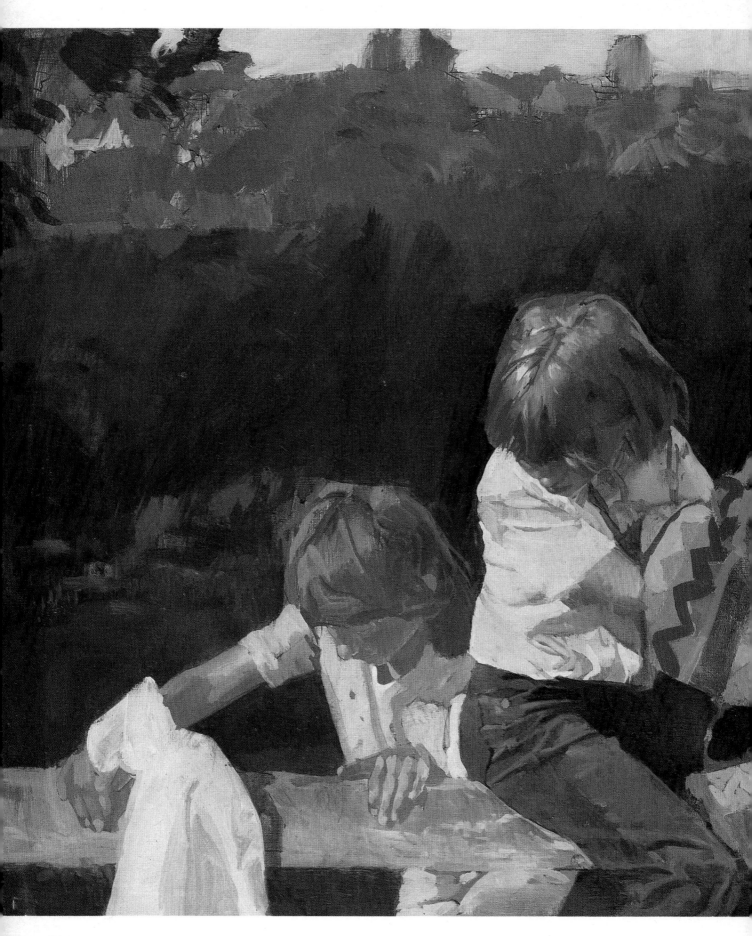

LEFT **Fig. 61** *The Fence* 1986 oil on board 30 × 40 cm/
12 × 16 in. Here again the landscape is that around my home.
The two girls are opposites in temperament, and I think some of
the rivalry between them comes across in this picture.
ABOVE **Fig. 62** Study for *The Fence* 1986 pencil with touches of
pastel

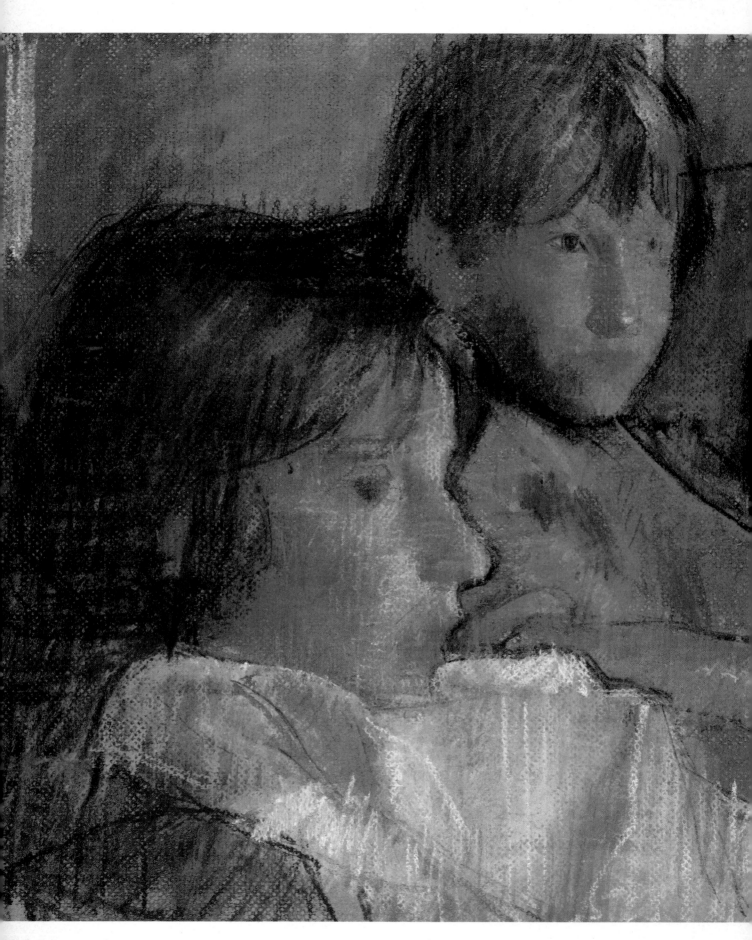

Double portraits

I also find it very interesting to paint double portraits, in a way which is an extension of the eighteenth-century conversation piece rather than of the conventional portrait. A portrait of two people together (or even of a person with an animal) is also a portrait of the interaction between them. They react together – and, an incidental advantage, people are also more likely to forget the presence of the artist, or the camera, so they are less self-conscious. I particularly enjoy painting my daughters together: I find it fascinating to explore the relationship between the sisters, the likeness with a difference, subtle variations on a theme.

LEFT **Fig. 63** *Katie and Hannah Watching Television* 1986 pastel 38 × 56 cm/15 × 22 in
OVERLEAF **Fig. 64** *Katie and Hannah Watching Television* 1986 oil on board 33 × 48 cm/13 × 19 in

Two versions of the same situation. Neither of the girls was paying any attention to me. The oil painting started from the idea of two figures, at either end of the picture. In practice I could not make this work, so I used Katie's battered Snoopy to unite them. The pastel is less finished, but it seems to me the livelier and better portrait

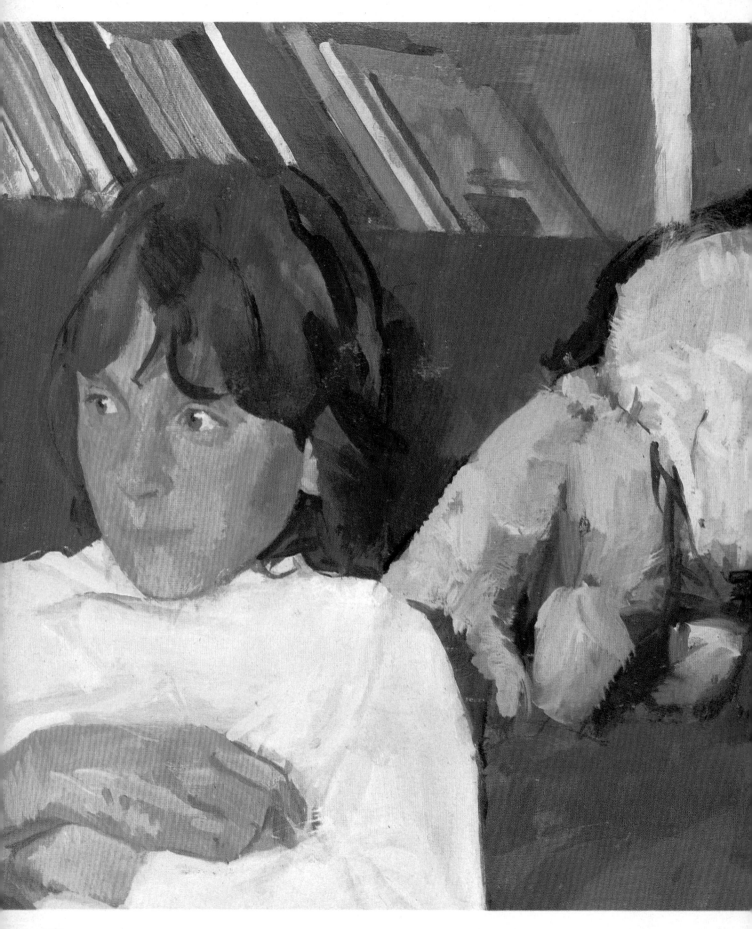

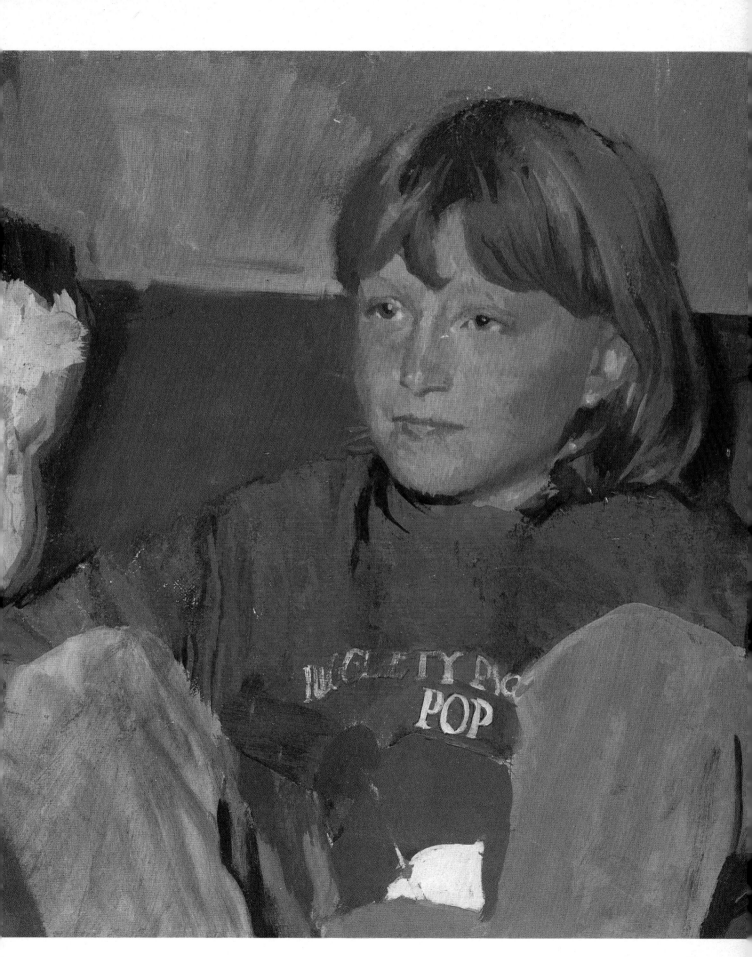

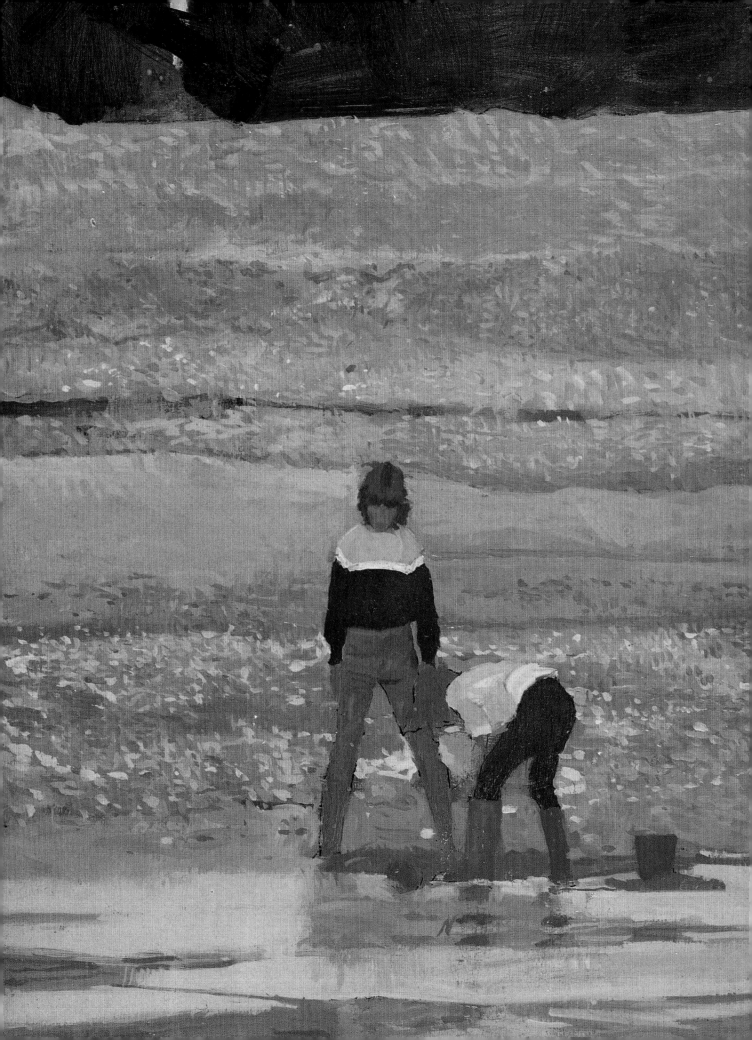

Fig. 65 *Girls on the Beach* 1987 oil on board 36 × 50 cm/ 14 × 20 in. I have always liked painting pictures in which bits of activity are set against large, flat areas. Here this is translated into a sort of conversation piece. The portraiture is attempted through posture – Katie, the critical spectator; Hannah, all activity.

Action portraits

One of the enduring traditions in English art is that of the sporting picture, a very accessible form of expression. It is horse-racing that comes to mind first in this context, but there are examples of other sports. It is perhaps largely because racing is so intimately connected with money that it has assumed pride of place – plus the fact that George Stubbs, one of the great English painters, chose it as his principal subject. Incidentally, the many portraits of grooms, trainers and jockeys in his paintings are among the finest English portraits, and marvellous examples of the complete figure as portrait.

Pictures of sportsmen, and in particular of people involved in horse-racing, have occupied me for many years. Among the reasons I find sporting subjects so interesting is that they are so pictorial, so decorative, if you like. You have, for example, jockeys' colours, the club colours of footballers, and all the paraphernalia of the track and arena – which is so useful in composition. Then, as well as the pictorial aspects, you have the physical and psychological characteristics of the players. I am particularly intrigued by the way character is demonstrated in competitive interaction, under stress. Finally, there is the fascination of trying to combine the distinctive action of sport with a portrait of an individual.

Fig. 66 *Jimmy Greaves* 1966 acrylic on paper 38 × 28 cm/15 × 11 in. This portrait was one of a series commissioned by *The Sunday Times*.

OPPOSITE **Fig. 67** *Sketch of a Jockey* 1987 oil on board 36 × 25 cm/ 14 × 10 in

Fig. 68 *Owners and Trainers* 1984 a study in pen and ink and watercolour